W9-BYJ-428

WALKING FORWARD
LOOKING BACK

John Labriola

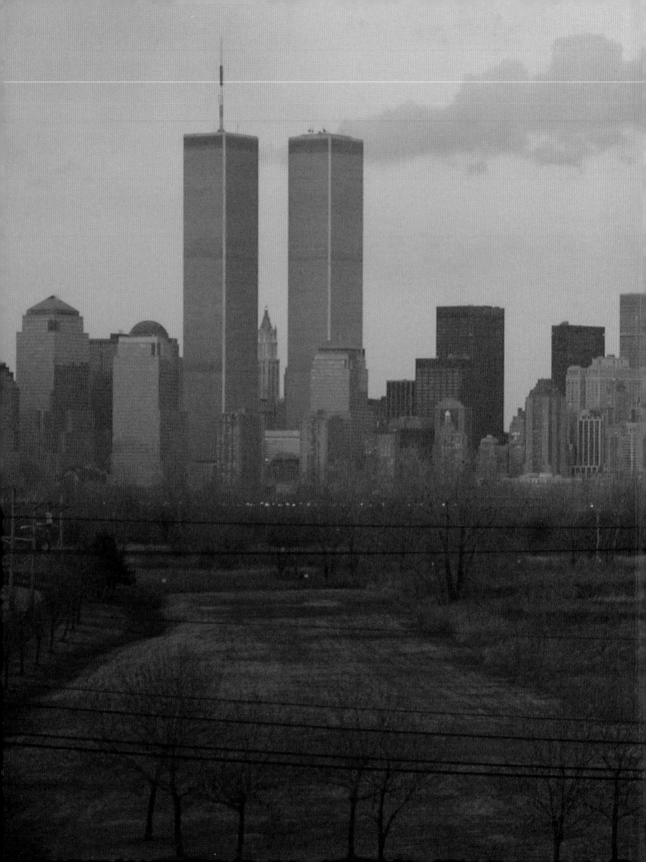

WALKING FORWARD
LOOKING BACK

John Labriola

HYDRA
PUBLISHING

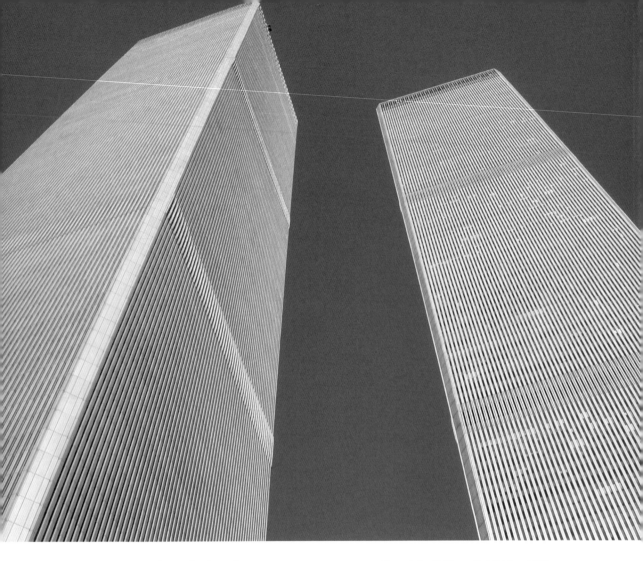

To Jenny, you are my home, thank you for giving me a
direction to travel on that fateful day; and to the army of
heroes; and in honor of the memory of the lost.
Let us never forget.

HYPER
PUBLISHING

First Published in 2003 by Hyper Publishing,
129 Main Street, Irvington, New York

Hyper Publishing
Publisher: Sean Moore
Creative Director: Karen Prince
Editor: Tricia Moore
Designer: Gus Yoo

First American Edition published in 2003
02 03 04 05 10 9 8 7 6 5 4 3 2 1

ISBN 1-59258-043-2

Printed and Bound in Great Britain by Butler and Tanner Ltd
Distributed by St. Martin's Press

Contents

Foreword, by Chuck Zoeller6

Introduction, by David Friend9

John Labriola: Who I Am10

September 11, 200113

Getting to Work19

The Meeting21

8:47am September 1122

In the Stairwell25

Anthony Barra's Story30

The Way Out41

Pete Demonte's Story52

Into the Light56

David Brandolo's Story88

Trinity Church93

John Fisher's Story, told by Ed Rolly98

The Tree107

Walking Away109

The Way Home125

On the Web126

The Emails127

Good Morning America136

Going to Ground Zero138

Mike Keogh151

Survivor Guilt152

The Smithsonian154

Time Life155

Chuck Zoeller156

The Anti-War Movement159

The Message from the Stairwell160

Gulnara Samoilova163

Anniversary of 9/11164

Judith Toppin's Story184

Epilogue188

World Trade Center, September 11th 2001190

Foreword

In this image-saturated world, countless photographs were shot at the World Trade Center on September 11, 2001. Yet we know of precious few still images made inside the Twin Towers after the attacks. As of this writing, we know only of John Labriola, who had a digital camera, and the presence of mind to document his painstaking descent from the 71st floor Tower 1— his personal odyssey out of the doomed buildings. Inside Tower 1 he shot 33 frames, the only known visual record from the stairwells of the towers, a rare and revealing glimpse into an unfolding tragedy.

The iconic news photographer Arthur Fellig, better known as Weegee, famously described shooting breaking news as a matter of "f/8 and be there." True enough, but Weegee's own work clearly transcended competent picture taking. Just as Weegee's best photographs expose layers of the human condition, John's photographs of September 11 are far more than matter-of-fact documents. With seeming prescience, he shot one of his first pictures of the day when he arrived at the World Trade Center for an early meeting with the Port Authority. His photograph of the soaring towers framed against a crisp blue sky was certainly one of the last photographs made before American Airlines Flight 11 slammed into the North Tower. At 8:47 a.m., Less than an hour after shooting that image, in a conference room on the east side of the the tower, John felt the building shudder violently. The rest became history as he calmly began to photograph, documenting ordinary people swept up in extraordinary circumstances.

John's photographs show us the evidence: a scorched lobby, water cascading down stairwells, the grim scene outside the towers. But his most moving and poignant images show office workers slowly filing down the stairs as firefighters try to cope with the disaster. In one of his most-published images, transmitted worldwide by The Associated Press, firefighter Mike Kehoe ascends the stairwell. Millions saw the photo, and many wondered about Kehoe's fate; he survived, but six of his fellow firefighters from Engine 28 did not. Another photograph shows the blurred image of a firefighter laden with gear, exhausted, climbing the stairs as people gaze after him in a mixture of shock and fear. This photograph, arguably more than any other, embodies the spirit of the people inside the towers that morning. The faceless firefighter epitomizes the hundreds of rescue workers who risked and sacrificed everything. John's work did not stop when he finally reached the street. Both towers would soon collapse into rubble. More than a few photographers braved the ensuing storm of dust, smoke and debris, but as John continued shooting, he captured an especially surreal scene as a lone businessman, briefcase in hand, crossed a street resembling a lunar landscape.

This unique body of work stands as a testament to John's courage and vision. The Associated Press nominated him for a Pulitzer Prize, and people around the world have responded to his images. If a fundamental ideal of photo-journalism is to inform by making an emotional connection with the viewer, then John certainly has succeeded. It remains a small miracle of September 11 that John was able to bring these photographs out with him, shedding some light inside the heart of darkness.

CHUCK ZOELLER,
Director of Photo Archive,
Associated Press

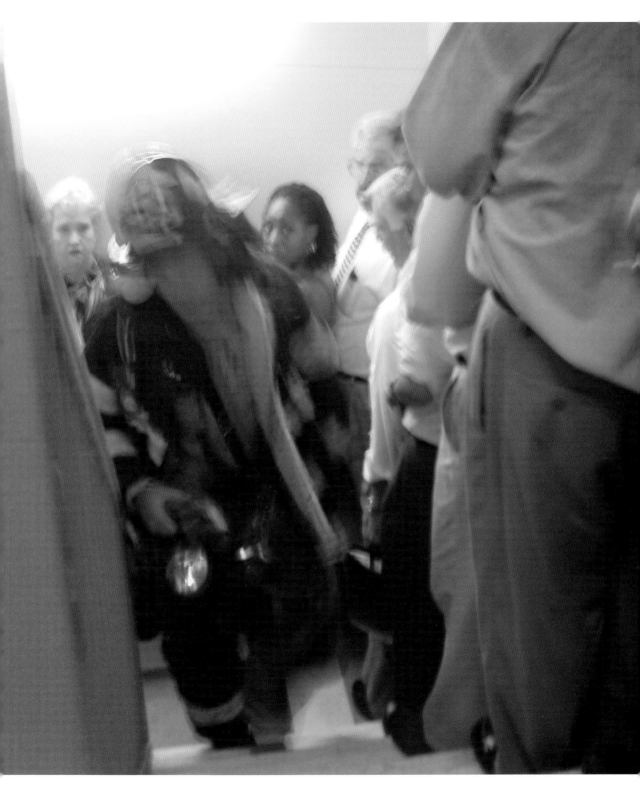

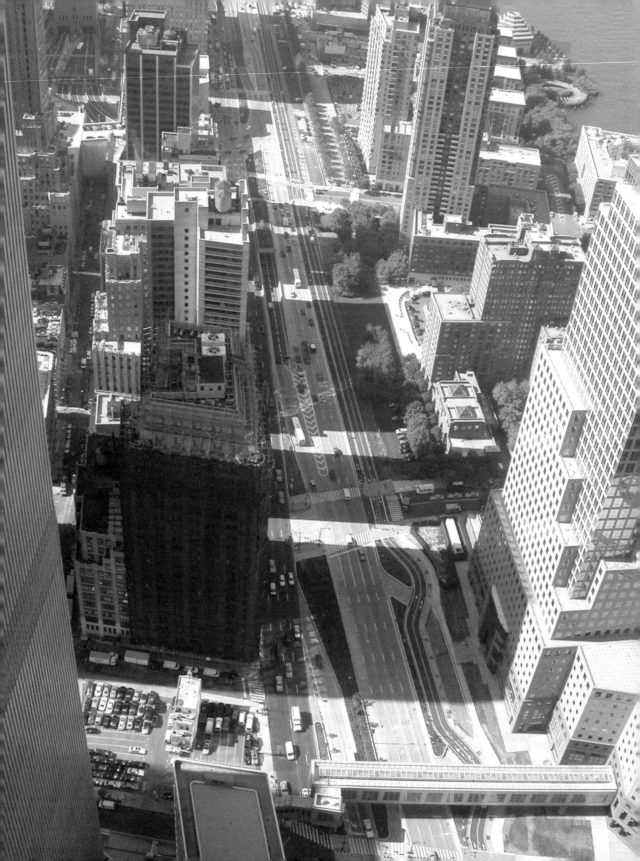

Introduction: THE MAN IN THE STAIRWELL

Tens of thousands of New Yorkers took pictures on September 11, 2001, the day that two passenger planes, hijacked by terrorists, were commandeered into the upper reaches of the World Trade Center towers. We have seen images from still photographers and television teams, policemen in helicopters and tourists with quick-snap disposables. We have taken in these visions of horror and heartache, absorbed the shock, and tried to come to terms with our anger, sorrow or loss. But there is still a special sort of coverage that is unique to that day. It is the work of John Labriola, unpublished in its entirety, until now.

Labriola, an amateur photographer of considerable vision and enterprise, was serving as a consultant to the Port Authority at the time, working out of an office on the 71st floor of Tower 1 of the World Trade Center. As he had done so many mornings before, Labriola shot photographs as he walked to work that day. A man with a discerning, observant eye, he photographed downtown street scenes, the East River, and the Twin Towers themselves. To Labriola, that late-summer day started like any other, one teeming with visual potential, full of fleeting moments to be cherished before they passed. As always, just for that reason, he had his digital camera at his side.

Then, like thousands of his co-workers, he stepped into the elevators of Tower 1 and ascended to his workday world. At 8:47am while attending a meeting in a small conference room, American Flight 11 struck the building seven stories above him. Within five minutes, Labriola was making his way down, joining worried colleagues in the crowded stairway. He had instinctively snatched up his bag with his camera before his left his office, and so for the remainder of the hour—the longest of his life—he took pictures. It would later turn out that Labriola was among only a handful of people to visually record events inside the World Trade Center that day. Others included French filmmaker Jules Naudet, shooting a documentary about a New York City firehouse (which eventually became the award-winning "9/11") and Eileen Hillock, a Morgan Stanley vice president working on the 56th floor of Tower 2. All of them came away with the last existing images of individuals they had seen alive that morning.

But Labriola didn't stop there. Once outside and out of danger, he continued shooting around the foot of the towers, near Trinity Church (where he sought refuge, and solace) and during his long, surreal walk to his sister's apartment several blocks away. In total, he took 110 exposures that morning. The result of his vigilance and prudence is an unparalleled, step-by-step account of four harrowing hours, committed in almost flip-book fashion to his camera's electronic memory banks.

Labriola's images are the frames of everyman. As if destined to the task, he was a stand-in for all of us that day: the man in the stairwell, with the steady hand and the gimlet focus. Like some spirit in the hereafter, Labriola was there to witness mortals go up and down to meet their fates. I believe he is alive today, in part, to share with us what he saw.

DAVID FRIEND,
Editor of Creative Development, Vanity Fair

John Labriola: Who I Am

I feel I should begin my story with an introduction about who I am, and what led me to be taking photographs at the World Trade Center that terrible day.

My childhood was unexceptional, in as much as I come from an ordinary, dysfunctional American family. My dad passed away in 1960 when I was an infant, leaving my mom to raise my eldest brother Frank, my sister Louise and myself. We left New York for the promises of a new life on the west coast, and when I was 7 my mom married again. We lived in a mediocre house in a middle-class neighborhood with good schools. My younger sister Anna was born in December 1970 followed a year later by Mia, and James 3 years after that.

I was the youngest student in my high school class, a decent kid, a good athlete, and despite suffering from dyslexia, a slightly above average student. I applied to St John's University in Queens, and was accepted into the liberal arts program as a pre-law student. For the next two years I kept my head down. Somehow I conquered or grew out of the dyslexia that had handicapped me since childhood, and despite smoking my fair share of marijuana and working full time, I managed to get good grades. in 1979 I transferred to the University of Arizona and changed my major to economics with a minor in management information systems. But although I did well academically I became bored with business, and changed my major to fine Art. For the first time in my life I felt that I was where I belonged. I was financially independent, I was growing up, and was happier than I had ever been. But, when I was 22 my mom and step-father both become ill. My stepfather suffered a heart attack and needed a quadruple bypass, my mom collapsed while taking a shower and had needed to have back surgery. So I moved back to Long Island thinking somehow that I could help, and build a future closer to my family. I found a room in a shared house near a shopping mall, and landed a job in a jewelry store. Somewhere along the line I had set aside art as a career to make enough money to pay the rent.

It became clear I wasn't going anywhere on Long Island. At that time, my cousin, Michael Labriola, was working as a sales manager for a cable company in Manhattan. Michael helped arrange an interview for a position as a computer operator, I was hired on the spot. This was 1983, I moved to Manhattan and traded the bohemian life in favor of a more secure half-life as a computer geek. In 1992 I became a computer consultant and began a working relationship with The Port Authority, with whom I was scheduled to have a meeting with on the morning of September 11.

Corporate life, admittedly, had treated me well, but I didn't feel completely satisfied. I became a dabbler in the arts and serious hobbyist. I wrote poetry, painted and took up photography. I carried a camera pretty much everywhere, and fancied myself a street photographer. Shooting sometimes every day for weeks on end, in between computer consulting gigs. I was 35 years old, living in Manhattan with great friends, and a loving family. I could afford to travel, to paint and take photographs, and to help my family. I was respected by my peers and had a promising future I had every reason to be happy....

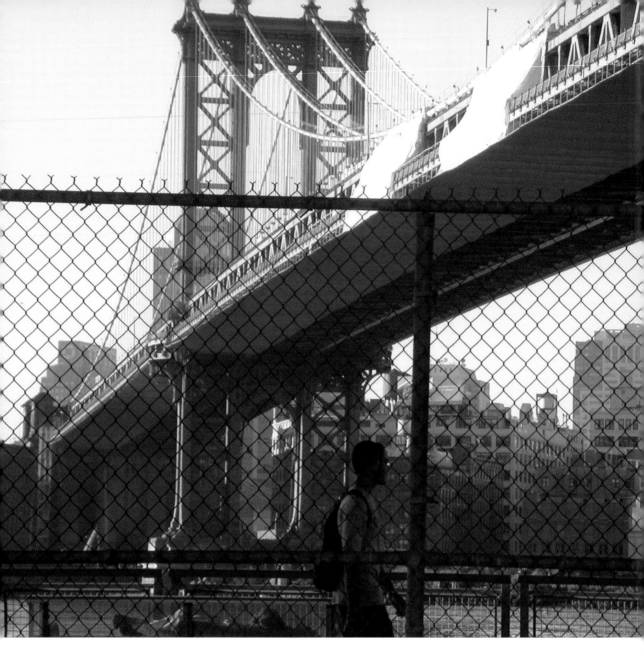

The Manhattan Bridge looking east from lower Manhattan.

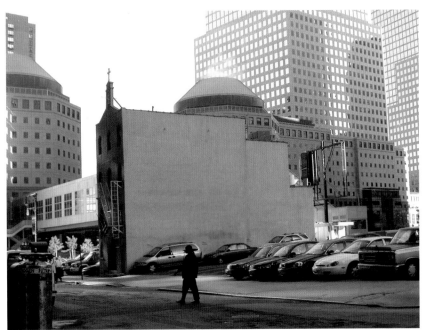

September 11, 2001

Jenny and I were living in an 800 square-foot one-bedroom apartment on the East side of Manhattan. A five-floor walk-up, it was a difficult climb made tolerable only by a 1000 square-foot roof terrace that we shared with another apartment—a poor-man's penthouse. I am a morning person, and that day I was up at 5:30a.m. I drank my coffee while watering the plants on the roof terrace, then I showered, dressed, kissed Jenny goodbye and was out the door before 7am.

My car was parked in a garage two blocks away on 88th Street and 3rd Avenue. My car—a 12 year-old classic 1989 Range Rover—was one of my most prized possessions. It hadn't seen much off-roading, but was ideal for climbing curbs and negotiating New York City potholes. Around 7:20 a.m. I entered the FDR Drive heading south at 92nd Street.

I had spent the summer doing a variety of short term consulting assignments and taking photographs pretty much every day, so it was painful for me to now be tied to an office. I had started a new contract in late August in Tower 1 of the World Trade Center. Labor Day through October was my favorite time of year in New York. The weather had been particularly beautiful, a string of clear dry days in the high 70's to low 80's. Space, time and weight permitting, I planned to carry a camera and to take a few photographs on my way to and from work, or on my lunch break. Since no one was paying me to take these images I needed to make cheap photographs. I also needed to travel light because I knew I would have to carry my laptop that day. In the weeks prior to taking on this new assignment, I had tried to keep a fresh battery and an unused memory card in the digital camera, which I carried in my backpack along with my laptop computer. I had been shooting well, and

Garage attendants chat at the entrance to the south pedestrian walkway over West Street.

I intended to keep it going if I could, despite my day job. The traffic in the city had increased since Labor Day, I didn't really mind, it gave me a little extra time to take in the tugboats and ferries working the East River. The sun was coming low from my left as I headed south down the FDR Drive. I remember thinking that Manhattan must have been perfectly lit if viewed from the opposite shore. As I approached the financial district I was tempted to jump across the river and get a few shots of Manhattan from the Brooklyn side, but there just wasn't time. At 7:45a.m. I exited the drive at South Street. If I wanted to make my 8:30a.m. meeting, I would have to settle for a few high contrast shots of the Manhattan Bridge looking east towards Dumbo and Brooklyn Heights, then quickly make my way west to find a place to park.

I followed South Street, under the Brooklyn Bridge and past the Fulton Fish Market. The streets were still wet and stinking as the market was shutting up after another day's work. Most of Manhattan is easily navigable, with its grid laid out neatly into east-west streets, and north-south avenues. But down in the oldest part of the city, the labyrinth of mostly one-way streets can reduce the uninitiated to tears. After much jockeying about, I parked in a lot on the corner of Washington and Carlisle, just east of the Westside Highway in the shadow of World Trade Center Tower 2.

It was 8:00a.m. and too beautiful a day to be inside. I stopped to take a photograph of a fruit vender starting his day on Greenwich Street, then walked north, into a site that took my breath away—Tower 2, stood alone, rising out of the shadows. I remember thinking how odd it was to see it without its twin, framed dramatically against a perfectly clear, intensely blue sky. I took a shot of the Greek Orthodox Church, St. Nicholas, which stubbornly shares its toe-hold in lower Manhattan with a public parking lot and the entrance to the south pedestrian bridge between West Street and the World Financial Center. I took one last photograph of the Parking attendants chatting by their booth in the early morning light, and at 8:07a.m. reluctantly made my way inside.

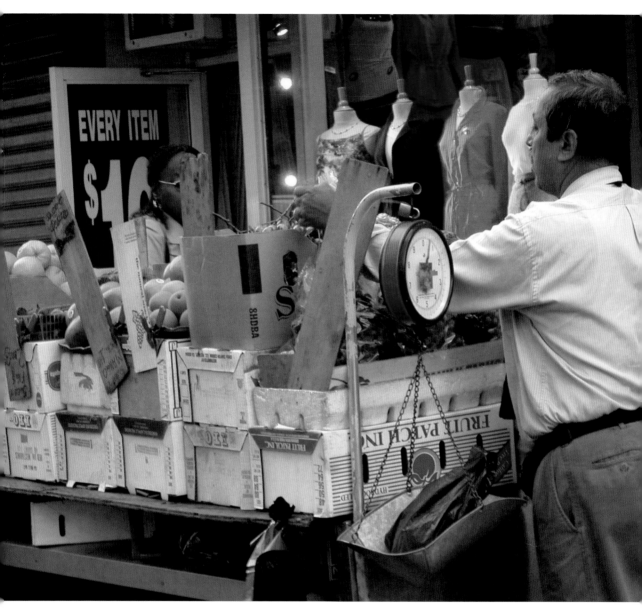

Fruit vender two blocks south of World Trade Center 2

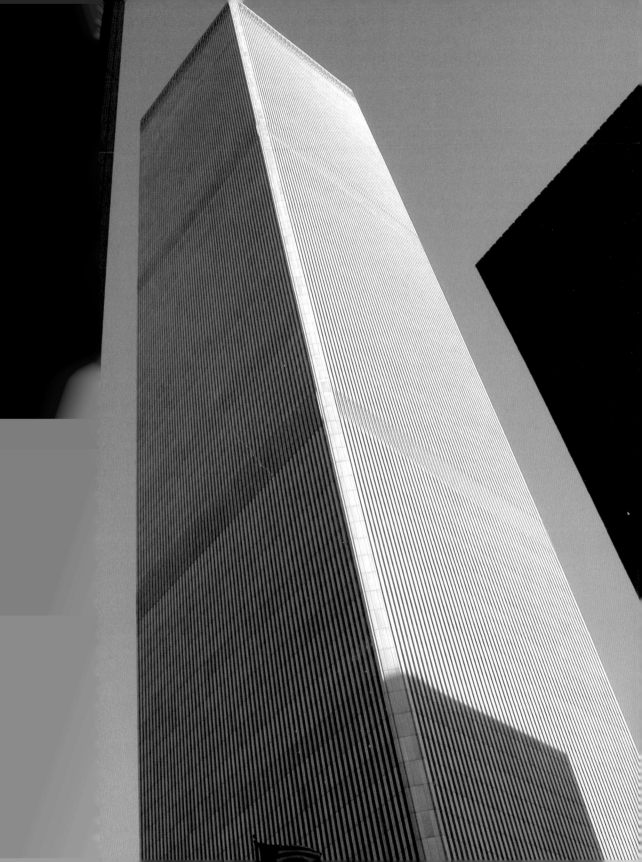

Possibly the last photograph taken of the
World Trade Center before the attack

Getting to Work

On September 11th I was due to attend an 8:30am status meeting on 71st floor of WTC Tower 1. This was my first such meeting since joining the Technical Infrastructure Group (part of Capital Programs Management within the Technical Services division of the Port Authority) two weeks earlier. I took the elevator up to the sky lobby on level 44 and crossed over to a bank of elevators that would then take me up to Port Authority Technical Services on level 71. It was now 8:15.a.m. I had just enough time to leave my backpack in my cubicle, take a couple of phone calls, and gather together my notes for the meeting. At 8:29a.m. I headed around the corner to begin work.

The Port Authority manages the bridges, tunnels, airports, docks, path stations, subways and light rails. These facilities rely on a significant amount of technology to operate. Some of this technology is up-to-date, while some of it dates back to the turn of the century. Whether the technology is to be maintained, adapted, or replaced, it generally must be integrated with systems that report back to the operators of the facility. This requires a wide variety of systems and communications infrastructure and an equally varied mix of technical specialists. My group was comprised of technical project managers, whose collective tasks ranged from replacing the 80 year old electronics and communications systems of the ventilation fans in the Holland and Lincoln Tunnels, to upgrading and managing the fiber optic infrastructure at each of the regional airports. Most of the time the group is scattered about doing fieldwork, so status meetings represented the rare occasion when everyone gathered in the same place at the same time.

In the two weeks prior to 9/11 I visited the ventilation buildings on each side of the Holland Tunnel, and inspected sites where new fiber optic networks were to be installed in concert with the new light rail system at Kennedy Airport. My group was planning the upgrade of the fiber optic infrastructure at LaGuardia and the proposal of new flight information systems.

The Port Authority maintained vehicles that could be signed out for field trips, but on that day I decided to drive my own car.

The Meeting

The first time I went up to the 71st floor I was struck by its relatively small size, despite the enormity of the building. Because of the great height of the Twin Towers a large amount of space was allocated to the core structure, which included elevator lobbies, bathrooms and stairways. The conference rooms were situated around this core. The remaining space was divided into small cubicles (with breath-taking views).

Our meeting was on the east side of the building. I sat with my back facing eastward, toward the door and the windows beyond. Garry Hundertmark headed up the group. His staff consisted of Paul Tava, Steve Worsthorn, Chris Reilly, Novelette Roberts, Larry Gardenhire, Tom Smith and Jeff McCormack. The only one missing from the meeting was Chris. We shared a few minutes of light banter as everyone took their places and settled in. Garry made some opening remarks then Paul Tava delivered his status report on the 1934 historic Art Deco building 1 at Newark Airport. The building had been moved 3,700 feet to its new location. It was being restored, modernized and expanded to include new facilities for Port Authority and Police Operations.

In additionto this, the old Port Authority Police and Port authority Operations building and control tower had been slated to be demolished so as to make way for a new terminal. This, of course, required the decommissioning of the existing infrastructures, and the installation of new technology and communications systems—to be managed within an extremely compressed time frame and without causing disruption to the busy airport.

8:47a.m. September 11

Without warning, at exactly 8:47a.m. the building was violently rocked in one direction and then shuttered back and forth until, after what seemed like an eternity, it finally settled. I heard what sounded like an explosion above us, but it was out of sync with the violent movement of the building.

Foolishly I tried to stand up while the building was moving and fell back into my seat. I remember reading that the buildings were designed to move, and had experienced that very thing two years before, when I was in the towers during a wind storm. Back then I had felt the odd sensation that something I knew to be solid was not really solid at all. The impact I felt now was like that, only magnified a thousandfold. It seemed to me that the building had moved a good five or six feet in each direction. We looked around the table at one another; Novolette had fallen, but none of us were hurt, and no one who'd been seated had been knocked out of their seat. I turned and looked over my left shoulder out the door, towards the windows. I saw papers fluttering everywhere, against an incredibly blue sky; for a moment I was

reminded of the Yankees tickertape parade, which I had watched years before, but any fleeting similarities were driven away by the sight of a ball of fire falling from above. There was a chorus of "Holy shit!" and "Oh my God!"s. Garry said immediately he thought that we had been hit by an aircraft, and that we better get the fuck out of there. Larry kept saying over and over that the building was going to fall. Tom and Jeff were helping Novelette to stand up and to release her grip on the conference table. There were no fire alarms or announcements but we knew we had to get out of there. Someone said that the elevators were programmed to immediately return to the sky lobby and that we would all have to take the stairs. As we left the conference room I remember thinking that it might be a long time before I could get back into the building (as a consultant I carry my office around in the form of my laptop computer) so I headed back to my desk. Garry must have been thinking the same thing, and together we made a loop around the floor to our cubicles. I grabbed my backpack, and then headed to the lobby.

In The Stairwell

The first stairway we tried to exit was blocked by the strong smell of smoke, the second seemed clear, and we joined the line of people already making their way down. We were in Stairway A on the north side of the building. It was slow going—like walking out of Yankee Stadium at the end of a game—and there were bottle-necks of congestion as people merged from the floors below. More than once we stopped for long, seemingly inexplicable periods of time, only to start down again. It was hot, people slipped on the sweat left by those who had gone before them. In places the smoke was pretty bad, people covered their eyes and mouths with whatever was available.

The narrow stairwell limited our view, allowing for only limited visibility ahead and behind. To add to our sense of isolation we were pretty much cut off

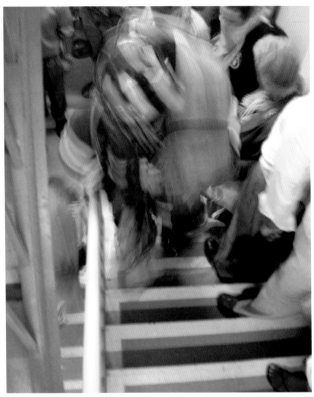

Workers press themselves into single file as firemen make their way up Stairway A of Tower 1.

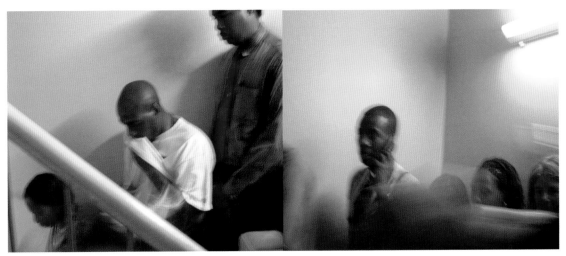

from outside communication. I tried countless times to make calls on my cell phone, to no avail. When the second plane struck we certainly felt it but had no idea what had happened, until a colleague received the news on his pager that commercial airliners had hit both towers and the Pentagon. The slow pace of our descent was frustrating; the cramped conditions, the heat and the smoke provided plenty of reasons to panic. Some of us were aware this was a terrorist attack, and many people in the stairwell had survived the bombing in 1993. Nonetheless, they did not lose their heads. It is incredible just how calm the people remained. Certainly there was enormous fear, but what was most was more apparent was deep concern for the burn victims being helped down from the upper levels, and for the exhausted firemen ascending the stairs with their terribly heavy loads. My first photographs in the stairwell had been of the firefighters, in fact it was only after seeing them that I remembered that I had my camera, and took it out of my backpack. My camera may have forced me to look a little more intently than most people but it was also a buffer, a

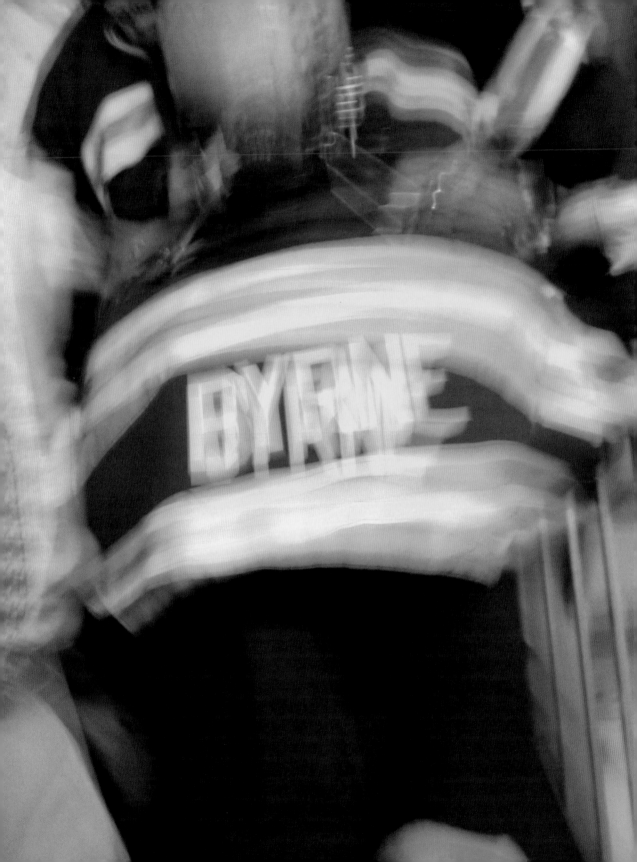

device that helped me to deal with the awfulness of what was happening to me, and everyone around me.

I cannot know what it was like for the people above the point of impact. I'd like to think that they carried on with the same selflessness, dignity and grace so clearly demonstrated by all of those around me in the stairwell; but I don't think any of us could have been prepared for what we were about to witness.

The amazing thing about that morning is I arrived at work at World Trade Center Tower 2 about 45 minutes later than usual because the traffic was so heavy. I used to catch the 7a.m. bus and be at work by 7:45a.m. But not on this day—I think the traffic saved a lot of lives that day.

I finally got to work around 8:30a.m., not officially late but late for me. 60 seconds is all it takes to get to the 78th floor—the sky lobby. There, I switched elevators, and went to the 97th floor. I dropped my bag, and then headed for the 94th floor, to my usual office. I put my time sheet in my computer, and went back to the elevator. Two other guys were in the elevator with me. Just before the doors opened, the car shook, and the light flickered out. The doors opened, and two women ran by screaming "We have to get out of the building!" I looked around, people were standing in confusion, some were running, papers flew past the windows followed by a huge fireball. The heat came right through the glass. I didn't know what was happening. My friends Manny and Bryan ran over to me and said "Something blew up outside!" Two things went through my mind—the 1993 bomb (which I had been only eight floors above that time) and the hour-long walk down the stairs.

I grabbed my bag, and started into the stairwell. People were moving along pretty smoothly and there wasn't too much congestion. I had bad thoughts, but I was cracking jokes to make it flow. Floor 91, 90, 89, 88…each floor consists of two flights of stairs, one opening out to a door to the next level, the other to a wall. At around floor 78 a Port Authority World Trade Center Security guy waved us through a door to that floor. My first thought was that he knew a shortcut. The whole crowd followed him and he closed the door. He held a small megaphone to his mouth saying, "Just relax, this building is secure. A plane has hit Tower 1, it's on fire, but we are safe here." This made me really angry. When the World Trade Center was bombed in 1993, security officials held us in the building then also. The Security guy told us to relax. Relax? Memories of the 1993 flooded my mind. I think that saved my life.

An announcement came over the main speakers: "Please stay calm. This tower is secure. Tower 1 has been hit by a plane. We are secure here, you may go back to your offices." I looked at Bryan: "Yeah right, we have to get out of here!" Security wouldn't let us leave but then another announcement came over the speakers. This announcement was scratchy, people were talking, and I couldn't hear clearly. I heard something about evacuation, and then the security guy walked away. Someone opened the door, and about 7-10 of us ran into the stairwell. The rest walked into the back room—to rest? to go back?—I couldn't believe they didn't come with us. I was the last through the door and closed it behind me.

We managed to get a few floors further down, I guess around the 71st floor, just walking and talking, and then WHAAAAM!!!!! The blast came down the stairwell, knocking us forward, almost to the floor. It was a sound I can't describe, because it was like no other sound I have ever heard. The building leaned all the way over and we couldn't stand up from the G-force. I remember looking at the floor and thinking "I'm dying right now". I waited to hear the building break and fall. You could hear the metal above us screeching and snapping. Then it stopped leaning and, slowly, came back to normal. We stood up. The wall right by my head was pushed out like an accordion. I looked back, there was no-one behind me. Some pieces fell from the ceiling, there was dust, smoke. I yelled: "Guys, go and do not stop!" I didn't understand, I didn't care—this was bad, and getting worse. My mind went onto auto-pilot. Unbelievably,

the stairwell was still pretty clear and we were moving steadily. It was getting a little more crowded further down. We paused to let the injured go past. People stopped to rest, some because they were feeling unwell. I told them not to wait too long, and they assured me they would keep going. At around the 20th floor, firemen were coming up. One stopped and asked me something like "How does it look up there?" I told him there were a lot of people further up. He looked up the stairs and made a face. He told us to keep moving, and his crew went up, mine went down. We found a young woman paralyzed with fear and crying. Manny put his arms around her and brought her with us. At first she wouldn't walk down, but eventually she came with us.

We finally got to the lobby. I had almost forgotten that a plane hit the first Tower. I still knew nothing about what was happening. The lobby was black, broken glass, no lights. "1993—this is 1993" was still going through my head "Something really bad is going on here—keep moving—we're almost out". To get out of Tower 2, it was necessary to go through the lobby, then up one flight to street level. We went up the stairs, and I looked out through the glass wall. I stopped in my tracks; outside all was black and burning, there were pieces of metal, glass, *everything*, strewn about. We got out. I wanted to see what had happened, but we were dragged away by a policeman, yelling "Don't look! no phones! move! get away!" We lost Manny and the woman from the stairwell at that point, now it was just Bryan and me.

When we got far enough away I looked up and saw both buildings ablaze. I couldn't believe it. My eyesight is poor and I didn't realize at first exactly what those "things" were raining down from the buildings. A co-worker we met in the street told us it was debris from a second plane. It was then that I realized what had caused the massive blast when we

were in the stairwell. I told Bryan it wasn't safe there. Suddenly people were running, screaming. We ran too. I asked a guy near us "Why are we running?" He said "There's another plane coming!" Aircrafts *were* flying by, but they were fighter jets! F-15s were flying over Manhattan. What the hell was going on?

We stopped at the ramp of the Brooklyn Bridge. I asked Bryan if he wanted to go across. He said, "Ok, I'm with you, man." I had a thought—what if they attacked the bridge? A cop was there, he said "Look, you're in front of City Hall right now, and this is a major target. I'd get out of here if I were you." We climbed the wall onto the ramp, and started walking. A woman yelled "Look!" and I turned to a sight I will never forget. My tower bellied out and crumpled with a sound you will almost certainly never know.

That's when it hit me—this was surely being broadcast live on T.V. and my mother would be watching, believing me to be inside the building. I didn't have a phone, I was on a bridge. A woman lent me her cell phone. I tried...nothing, tried...nothing. I'm no good with cell phones. She dialled for me and it rang! My brother answered, his voice was a crying voice. I said "Hello" I thought the phone would cut out, so I just yelled "I got out! I got out!" The whole house was screaming in the background. They had believed me dead. I should have been dead.

The list of friends lost to that day is too long. 94 people died in my company alone and there were also those I knew outside of work. Then there is the overall death toll. Coming so close to death and surviving not just one, but two terrorist attacks, has scarred me mentally. Months of memorials drained me. Counseling helped a lot, but the path to recovery is not smooth; some days I feel better, some days worse. As time moves on I'm sure I will be ok, it's just a long road........

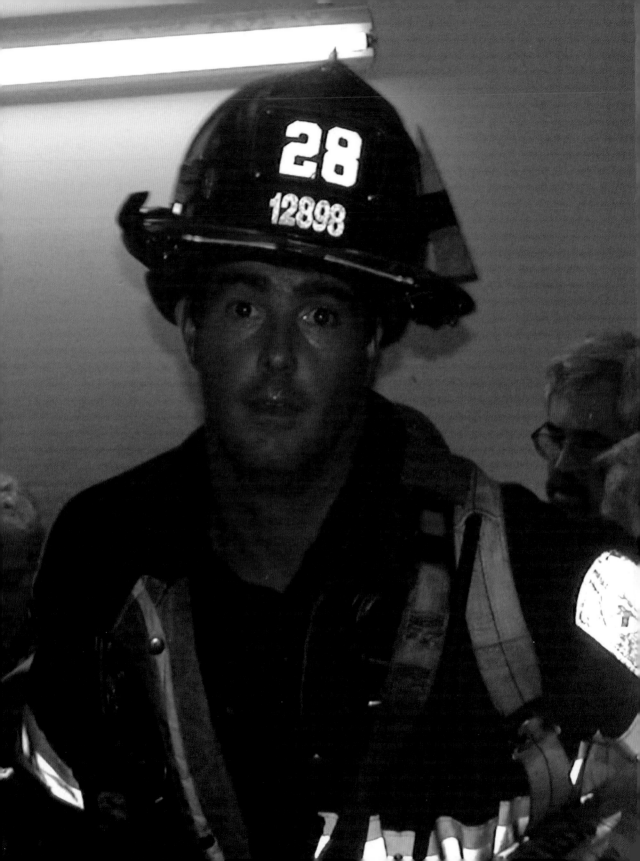

Civilians were the first responders, selflessly pitching in to help whoever was in need. But it is the firefighters who truly represent the courage and sacrifice of all those who gave their life that day. More than any of the other images I captured on that day, these are the ones that haunt my dreams. Many are blurred, almost abstract. I have searched the images and my memory for some detail of their faces, but they remain ghosts.

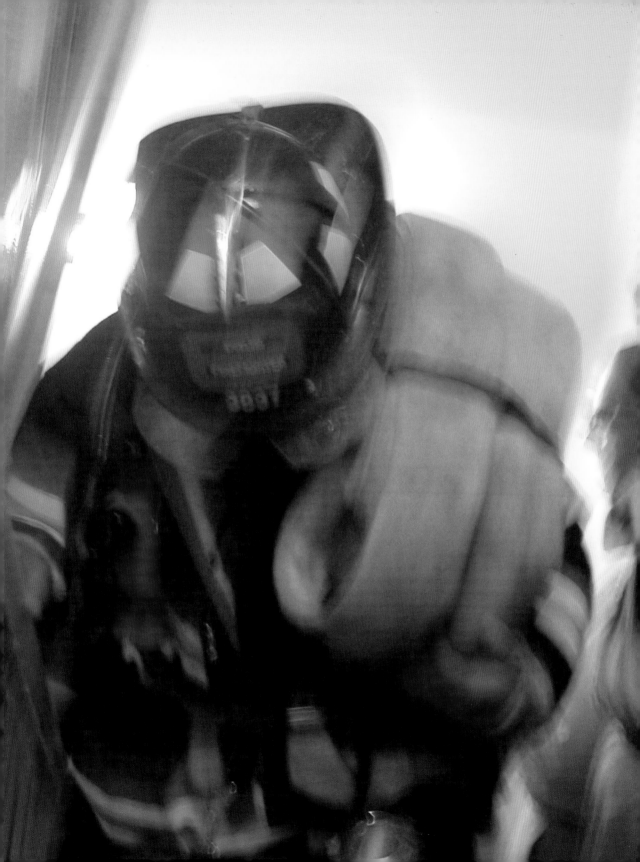

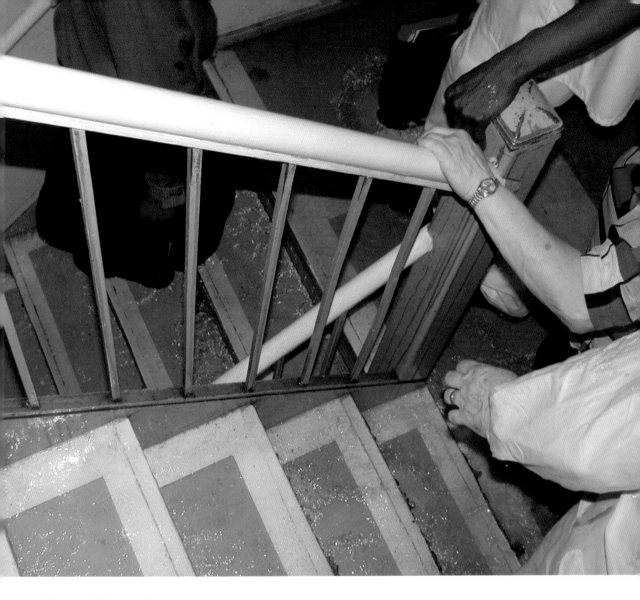

The Way Out

As we neared the bottom the pace began to pick up, leaving little time for contemplation or photography. Water was flowing now down the stairs along with us, and some women abandoned their high heels. The stairs led out to an emergency exit on the north side of the tower. From here, under normal circumstances, you could walk east into the courtyard or head west towards West Street and the north pedestrian bridge. Because of the amount of debris falling from above both these routes were rejected by the rescue workers. We were directed back into the building and into the balcony area that overlooks the glass-filled lobby of Tower 1. I stepped back from the flow of people long enough to take a photograph the lobby (and to gain the disapproval from one of New York City's finest).

I was intimately familiar with the lobby, having worked on the security system and network that controlled the video cameras a year and a half before. I checked out the surveillance cameras, wondering if any of my colleagues would have headed to the command centers, and if by chance they were watching me now. Just then the sound of something falling in the

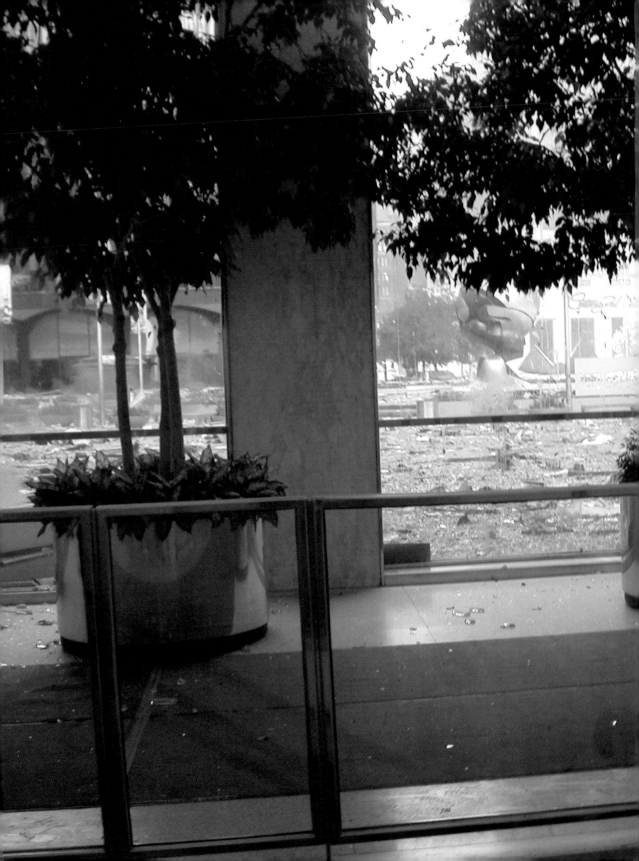

Courtyard full of debris,
from the balcony of
World Trade Center 1

In stark contrast to the cramped stairwell, the glass-walled lobby was buzzing with activity. I could see the now empty workstations where operators normally checked visitor credentials, verified appointments and issued temporary badges. I could see dozens of firefighters standing near a bank of elevators, and a group of officials gathered at a makeshift command station in the southwest corner of the lobby. Beyond them I could see fire trucks and emergency vehicles parked near the lobby entrance on West Street.

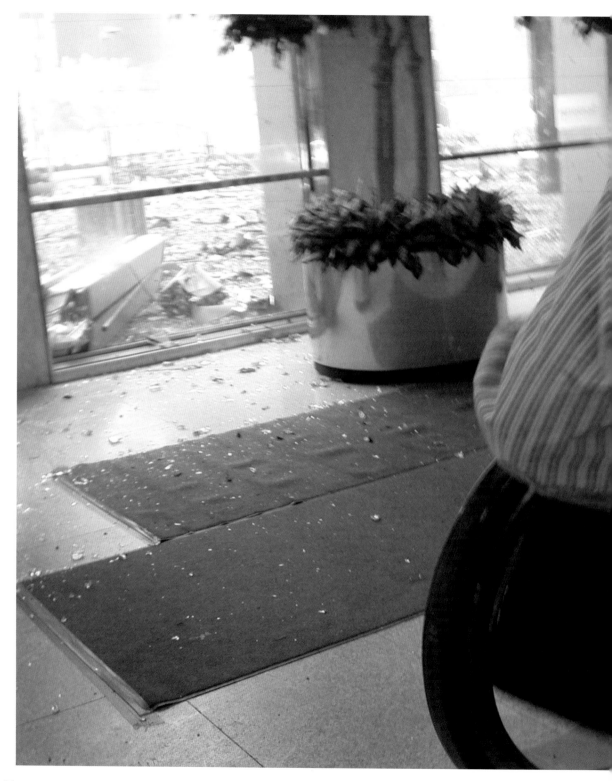

courtyard shifted my attention. An object had hit the temporary grandstand erected for lunchtime concerts. At first I thought it was a part of the air craft, but the sheer size and amount of debris made me realize that portions of the building were coming down. Another object hit the courtyard and then I noticed that one of the large, east-facing plate-glass windows in the lobby had shattered, leaving shards of glass everywhere. I remember thinking that his could not have been caused just by falling debris, and I could not understand how an impact 80 floors above me had blown out the windows in the lobby.

I rejoined the flow of evacuees being directed down the escalator and into the lobby. There was water falling everywhere, indicating that the extent of the damage above was of a graver nature than we could have imagined from the stairwell. Half way

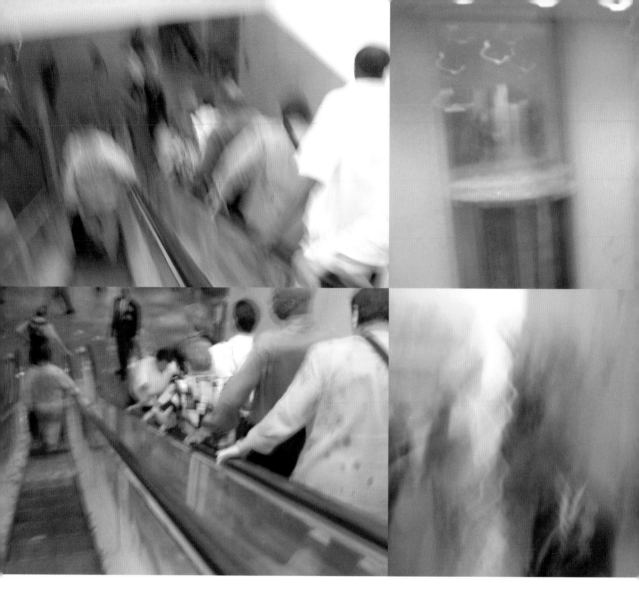

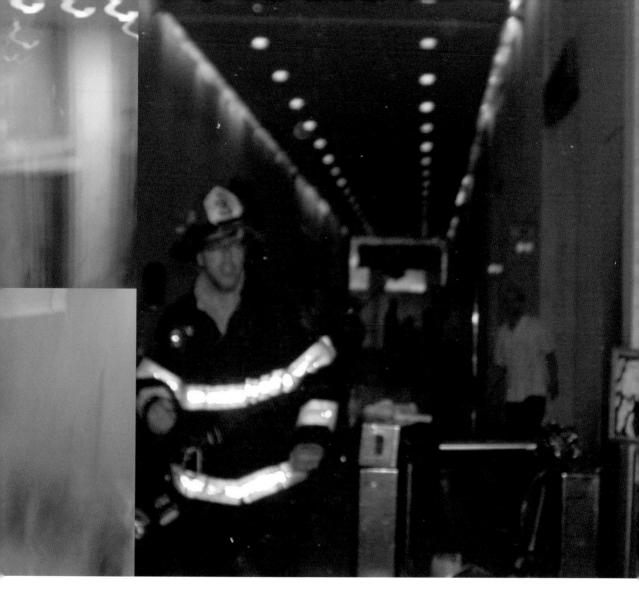

down the escalator, sheets of water flowed from the ceiling, above and over us like a waterfall. The escalator deposited us in what was now a glass-strewn lake, causing yet more distress and pain to the barefooted women who had discarded their shoes in the stairwell.

I stopped to help a man assisting an elderly woman through the water, then stepped to one side as the current of evacuees continued surging forward. It was especially important for us to stay focused in areas where we had to walk through water, as water and debris was falling around us. Most were eager to comply, and calmly but deliberately vacated along the prescribed route. As I stood by the turnstiles in front of the central elevators, I looked around the once-familiar scene. I paused long enough to take an shot of a burnt sign, a fireman, and a woman with an open red umbrella, wading through ankle-deep water.

The rescue workers had things pretty much worked out by the time we got to the lobby. They were lined up within earshot and view of each other to lead us along the pre-determined escape route. They didn't have much tolerance for stragglers, and their continuous barking and encouragement to keep moving kept rubber-necking to a minimum. I stopped to photograph two firemen standing before an escalator loaded with evacuees coming down into the lobby.

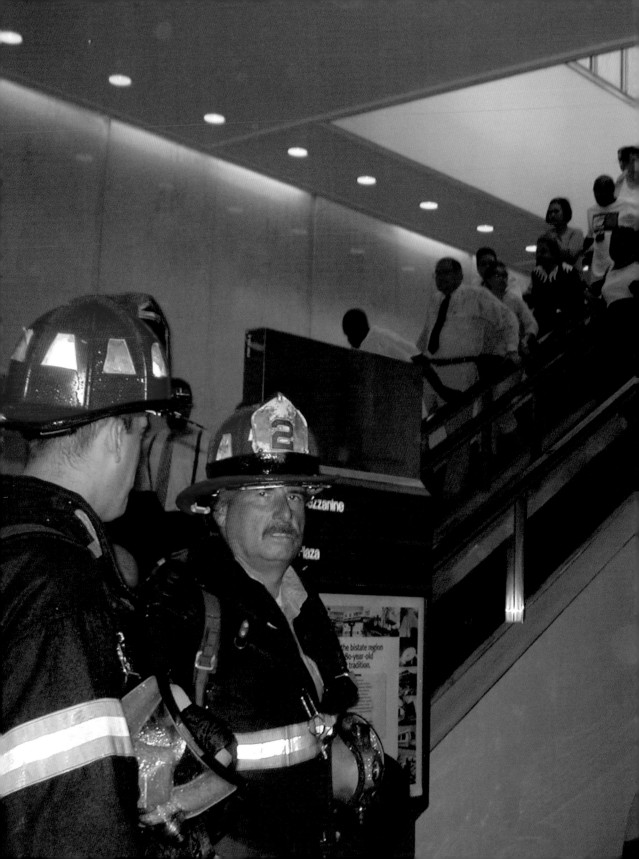

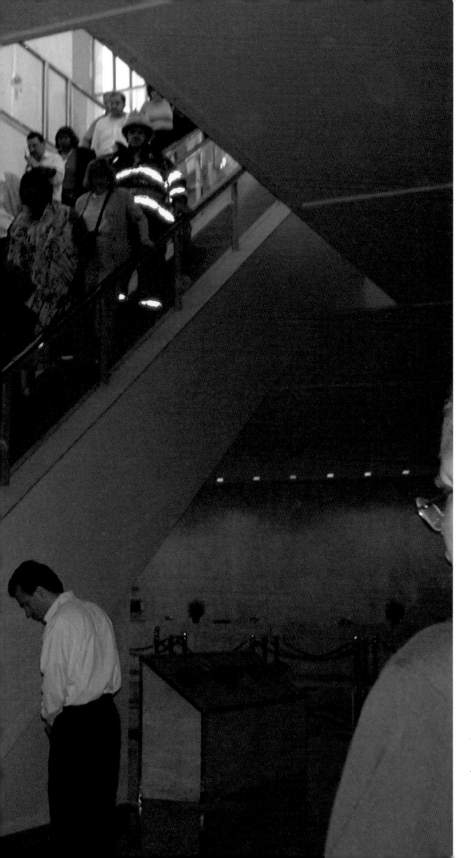

*Firemen Keith Rona and
Sergeant John Sheehan in
the lobby of Tower 1.
John survived, tragically
Keith did not. Keith's
father, also a fireman
and in the towers that
day, survived.*

51

PETE DEMONTE'S STORY

There are many moments in one's career that are defining. However, the events of September 11, 2001 are forever embedded in my mind. At times, the memories are just a swirl of images, sounds, and smells. Other times, they are sharp and clear. On that day, there was much bravery and courage, not only from my fellow officers, but from ordinary people. I guess, Henry David Thoreau was right when he said, "The hero is commonly the most simplest and obscurest of all men". The events of that day are well known, so I will tell them as I lived them.

On that day, I was assigned as the bike patrol supervisor of the Manhattan Traffic Task Force. Two of my officers and I were on patrol near the Waldorf-Astoria Hotel at 50th Street and Park Ave in NYC. At 8:46a.m. a call came over the radio that a plane had struck the World Trade Center. We knew we needed to respond immediately and since it would take some time for us to ride downtown on our bicycles, in order to expedite our arrival at the site I commandeered a passing van, threw our bicycles in the back of it and told the driver to take us downtown. Understandably, the gentleman became quite nervous drove very slowly. I had him pull over, unloaded our stuff, and was relieved when I saw a police car nearby. I loaded my bicycle into the car and order them to drive me downtown. On our way down to lower Manhattan, we could feel the tension. Something was amiss. I called my wife at work. I always tell her about the goings on in the City prior to her hearing them on the news and that day was no exception. I called and told her that a plane had flown accidentally into the World Trade Center that we were on our way down there to help; I would call when I could, and that I would be late home that night.

As we got close to downtown, I got out of the police car and cycled the rest of the way as it was faster. I remembered riding past the Mayor and the Police Commissioner and being struck by the fact that they did not look confident. I remember riding through a surreal world of building pieces, airplane parts and body parts strewn all over the street. As I looked up, I saw the smoke and flames issuing from the building and I just knew this was very bad. I propped my bicycle against the door of the World Trade Center, immediately entered and began evacuating people. It was moving orderly but slowly. People were sort of dazed. I was concerned that the revolving doors were preventing people from exiting quickly enough, so I had a maintenance man fold them back in order to have people leave the building more freely. I remember telling people to move rapidly and to move up onto Broadway which was a block away from the Trade Center. As the scene was so disastrous, I was telling people to not look behind them, but continue to look forward to where they were going. As I was assisting people in leaving the building, I saw a flash go off behind me. I felt angry. I thought to myself, "this is not a f.....g tourist attraction". I don't recall saying anything to the photographer, but I know I shot him a disapproving look. Little did I know, that our lives would become intertwined, that I would come to call him a good friend, and that his photographs would chronicle the events of that day, the people who left the building and those who didn't.

When I saw that people were evacuating at a steady pace, I went down to the Mall level of Tower One in order to make sure there was an orderly evacuation occurring there. In the Mall level, I saw Sergeant Timothy Roy, a friend and a member of my command, helping a burn victim. I don't know why I was surprised to see him. I almost greeted him a bit too enthusiastically considering the circumstances. He looked at me, responded, and went back to helping the person. Things were so surreal. However, unbeknown to me, I would be one of the last people to see him alive. How many other people did I see that day, in their last moments of life? I continued to lead people out and made sure they stayed calm. Many were telling me about the destruction they had witnessed, about the amount of bodies that were thrown about, they were bloodied, scared, some were burnt, other were drenched from water coming from the sprinkler system. One woman hysterically cried "there were bodies everywhere". While I was in the Mall level, I had tried several times to call my wife from my cell phone, but

I could not get a signal. I wanted to tell her what I was seeing, the enormity of it. We talk about everything related to our work and this was no exception. I tried one last time and finally got through. I told my wife of my location in the Center and that we were helping a lot of people to get out. I felt conspicuous being on the cell phone and wanted to hang up and get back to the evacuation. She told me that she and her co-workers were listening to the events unfold on the radio. I told her that I loved her and just before we said goodbye she told me that another plane had crashed into the Pentagon. When we discussed the events of that day, she said that telling me about the Pentagon had been almost an afterthought, but that she wanted me to know what was happening elsewhere. Having this information, made me realize that this was not an accident but a terrorist attack. Knowing this, I immediately headed out of the Mall level to confer with the Deputy Commissioner who I knew was in the area. I wanted to tow all vehicles from the area as terrorists have been known to plant explosives in trucks to kill and injure the rescue personnel.

As I left the Center, I grabbed my bike so I could ride to find the Deputy Commissioner, and I heard a loud rolling rumble. I knew what it was, but turned anyway, and saw the top of Two World Trade Center beginning to bend and fall. I jumped on my bicycle and road as fast as I could. All the while, telling people to run and to get out of the way. I managed to stay ahead of the large, boiling cloud of smoke and dust which threatened to engulf all in its path. I finally made it into the clear. I didn't know where most of my colleagues were. Initially I thought that at least 25 officers were lost just from my command. I was happy to find out that most of them made it out alive.

Unbeknown to me at that time, my wife had heard on the radio that both of the towers had collapsed. I knew that she thought I had died in the collapsed. It took three hours for me to find a working telephone to call her to let her know I was OK. I was on my way back to help search for my comrades when Tower One collapsed. I had used up all my luck that day. I was there when they pulled the last survivor, a Port Authority Police Sergeant out of the rubble. For the next several months, I went down to the site every day, helping to dig, to look for my friends, and to

make sure vehicles did not clog the streets so that all personnel and heavy equipment could reach the site. For my actions that day I received departmental recognition for "Extraordinary bravery, intelligently performed in the line of duty at imminent and personal danger to life".

A flood of books came out after September 11th. Then, one day at work, someone had a book that had my picture in it. When I looked at the picture, I immediately remembered the instance when the flash had gone off. I decided then to contact the photographer as he probably was concerned about who had survived. I also wanted to thank him for taking such historic photographs and to tell him that I was unsure if I had verbalized my thoughts when the flash went off, and if I had, I was sorry. What was most important about his photographs was that for me, they brought clarity and reality to the surreal quality of that day and reminded me, that I was really there and not just having a "bad dream".

I am a peer support officer for POPPA (Police Organization Providing Peer Assistance) and have been for several years. As part of our training, we received instruction in Critical Incident Stress Management. The purpose of such training was to hopefully respond to precincts where officers had been injured or killed in the line of duty. None of us ever expected to use the training in the manner that we did. In the months following the disaster, I was involved in conducting debriefing sessions for those who were first responders, those who worked in the area after the incident, and those who experienced frustration at not being able to respond immediately.

The debriefing process is a very structured and contained an interview that focuses upon the events rather than the feelings associated with a critical incident. One of the questions asks "what good do you see coming from this event". I often found it difficult to ask this question, as what good could possibly come from such a tragedy. In one of our e-mails, John had told me about his grandmother's statement that "gifts come from tragedy". I was struck by that notion and began asking the question in that manner. And, it was true, there were gifts that came from that tragedy, in friendship, and in renewal and reaffirmation of the faith in mankind.

Exiting the mall near Borders Books, under WTC 5, I was almost outside

I made my way out into the mall through lobby doors that had been pushed outward. Once in the mall it seemed that half of the store windows had been shattered—once again the level of destruction didn't make sense. I followed the directions of the rescue workers as I walked east through the mall, finally taking the escalator back up to the street-level exit under building 5.

At the top of the escalator I paused to take one last photograph of a New York City policeman helping an evacuee off the same escalator I had just come up. The officer paused for a second as if to chastise me for lingering long enough to take the picture, but instead turned back to help the next person. I took one last look inside, turned and exited into the light.

Police Sergeant Peter Demonte guiding evacuees to safety

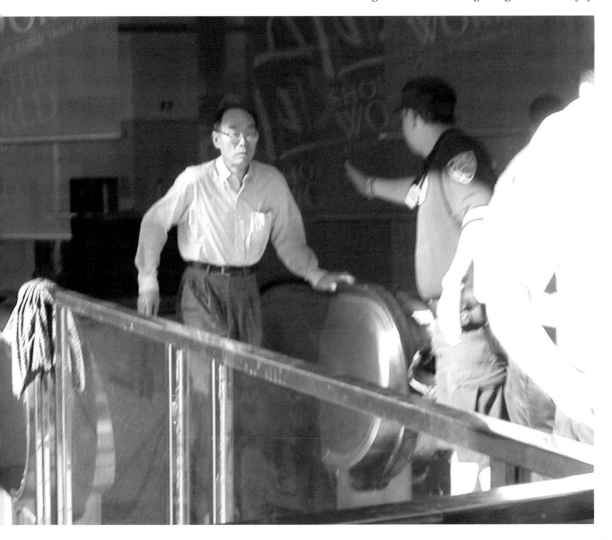

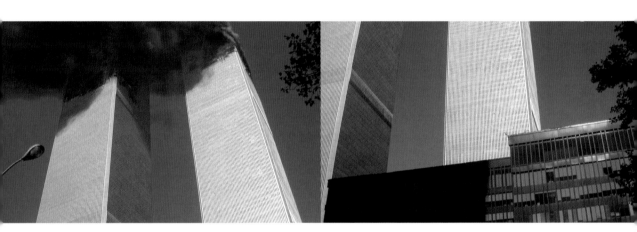

Into the Light

I exited the building at a half run, urged by rescue workers, some with megaphones, to "Keep moving" and "Don't look up". I noticed that many of the rescue workers were themselves looking skyward, and of course the first thing we all did was turn around and look up also. We spilled out onto Church Street and joined the thousands transfixed as they stared in horri-fied fascination at both towers ablaze. Until now most evacuees didn't have the time to take in the magnitude of the destruction; here in the open air the reality of what had happened unfolded before us.

I photographed the surreal vision of the towers burning, trying to capture the whole of it by taking multiple frames. Watching a police helicopter circling

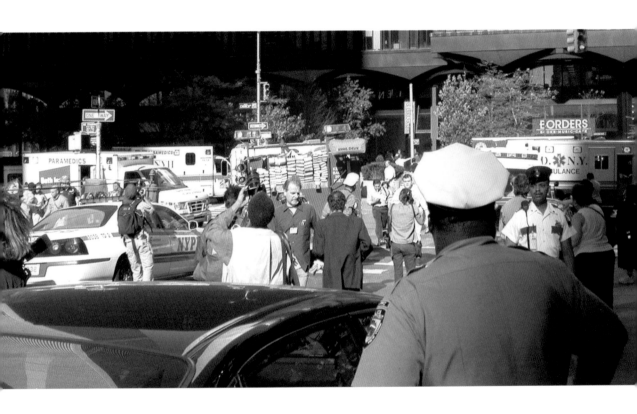

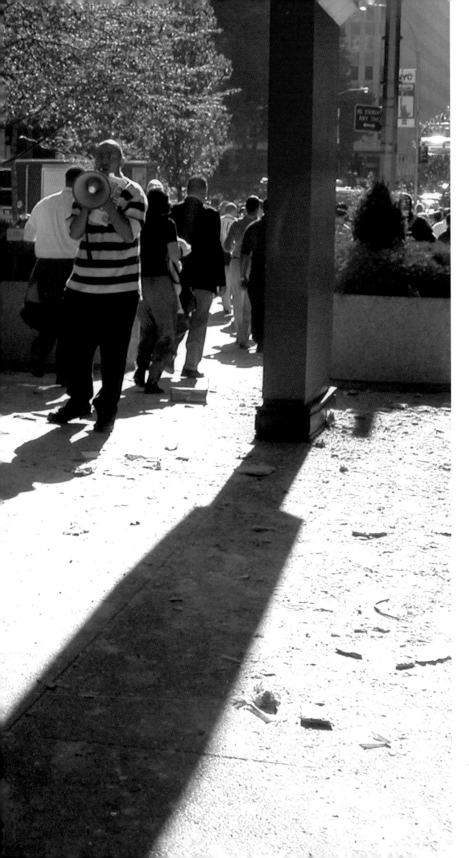

Outside, rescue workers
urging us to move to safety.
An emergency worker
with a megaphone orders
us not to look up

59

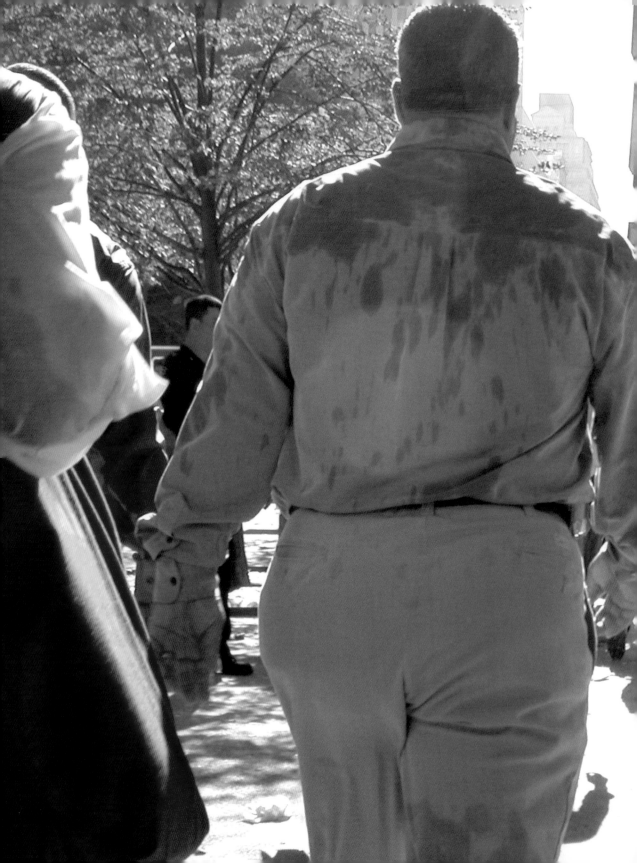

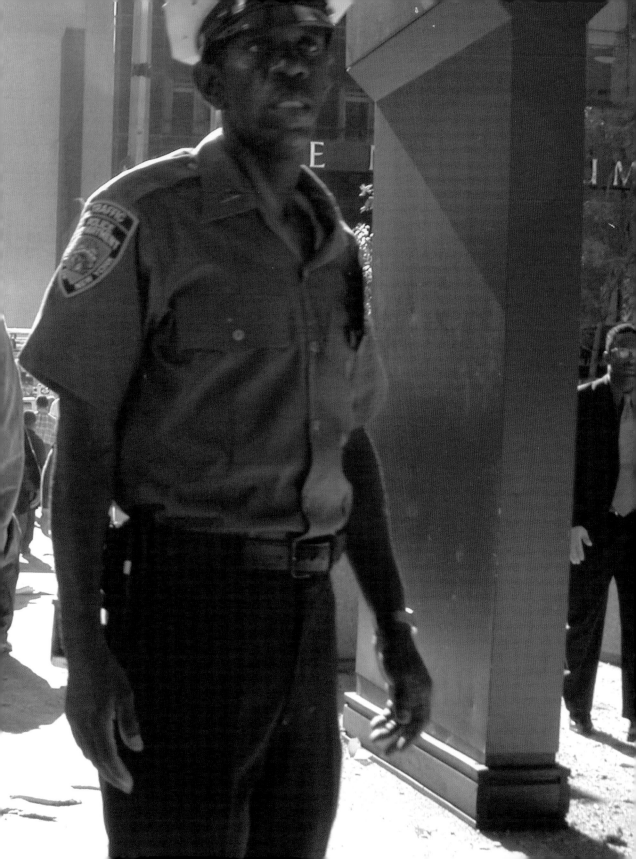

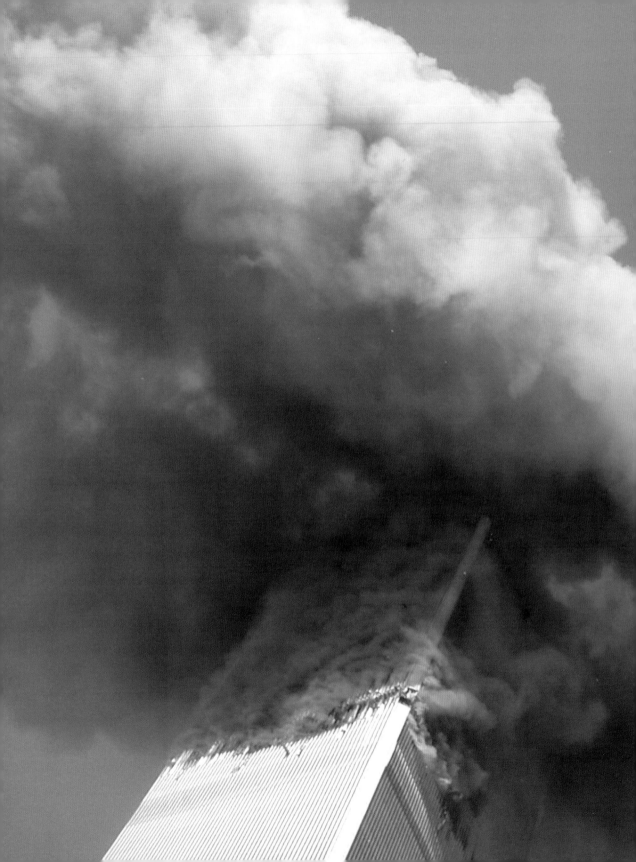

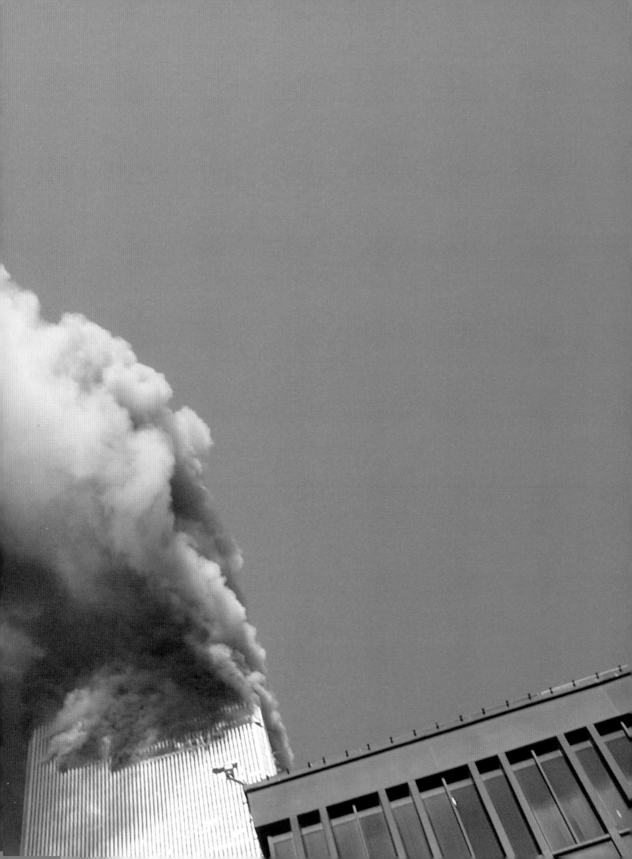

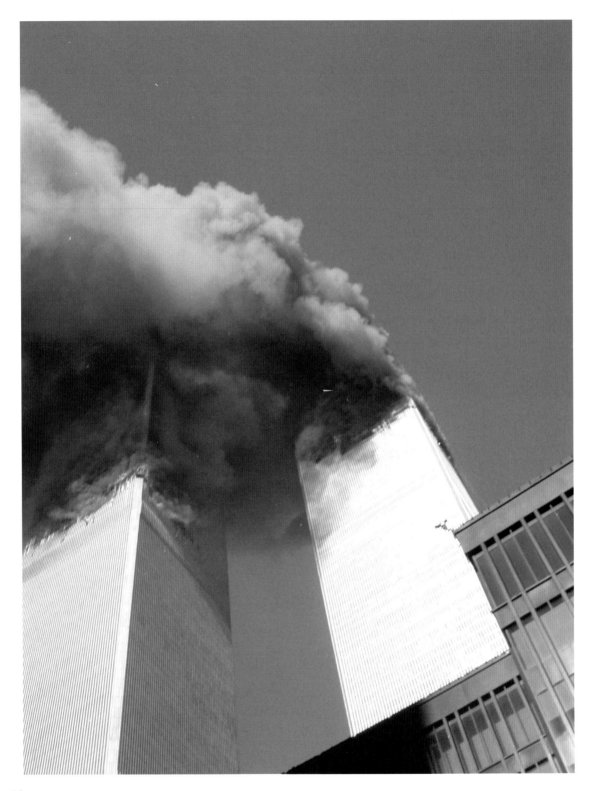

Left: The towers burning from Church Street near St Paul's cemetery

Right and Above: Running and shooting from my hip

Below: Looking back towards the way I had just come

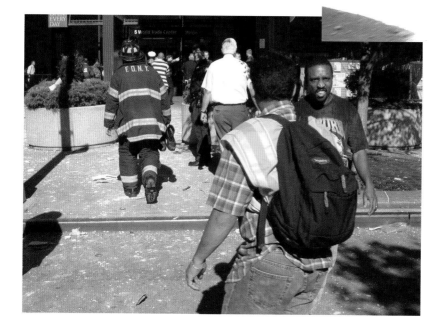

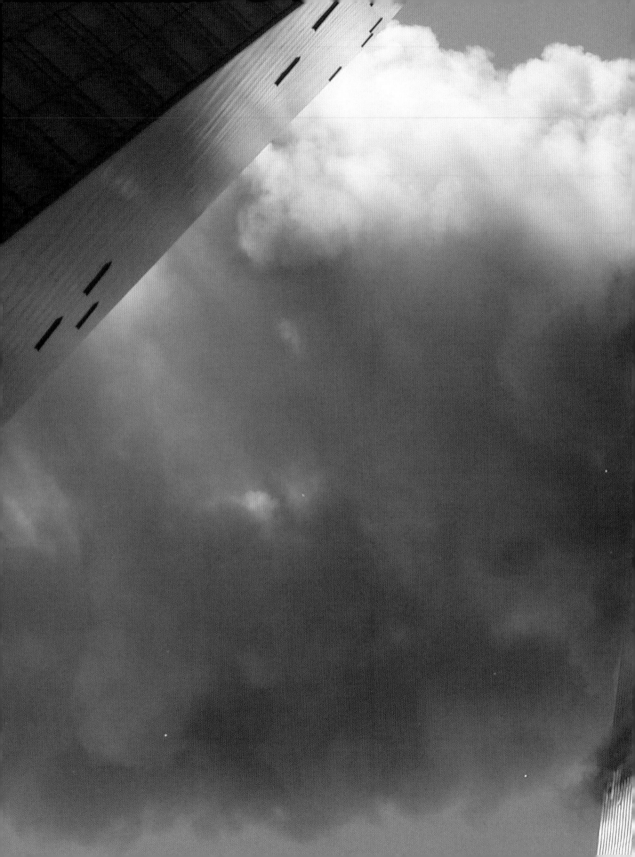

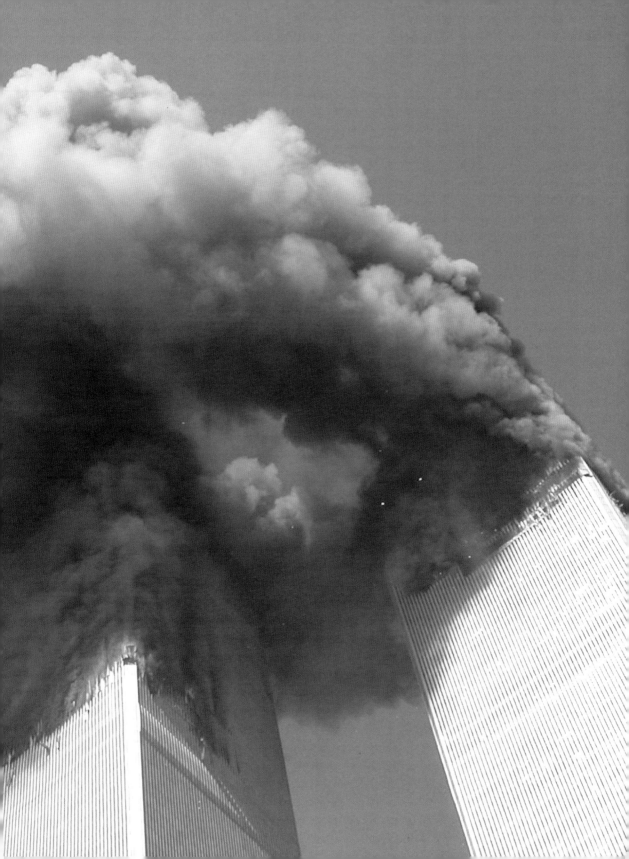

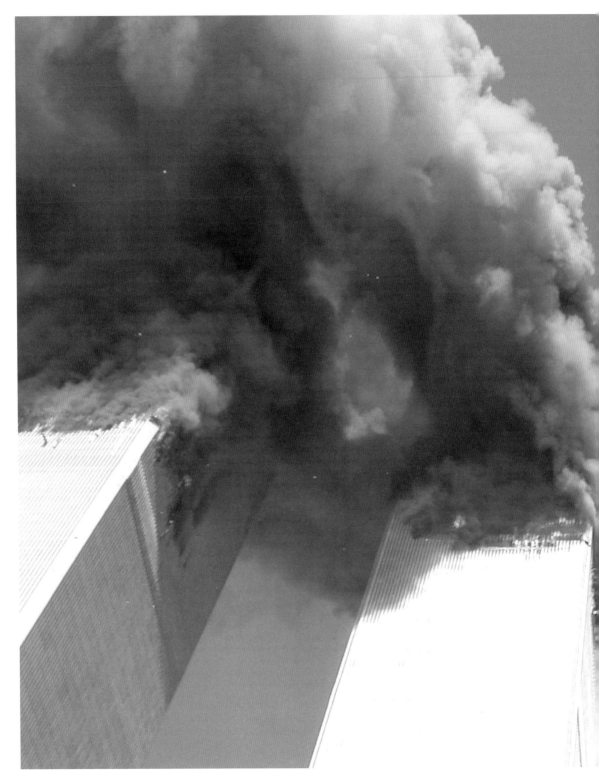

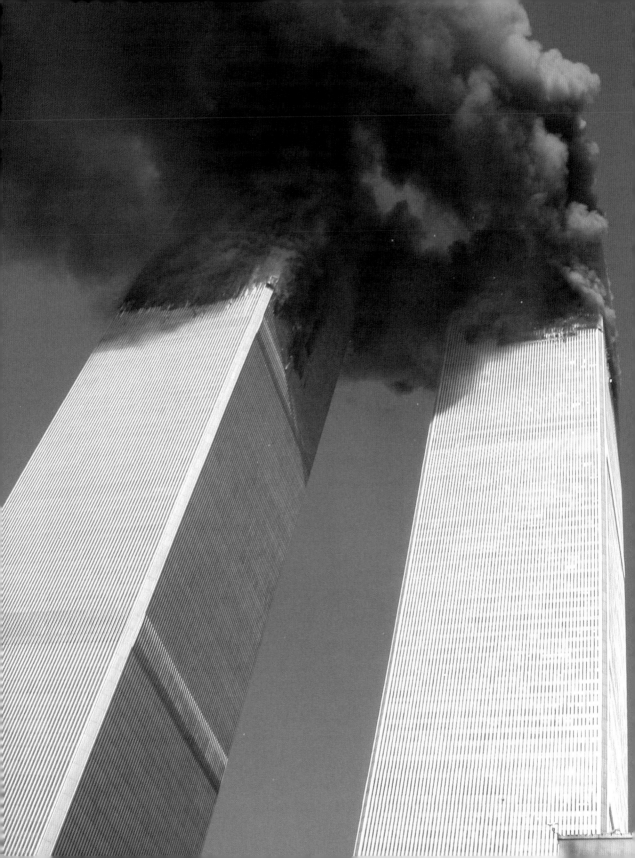

The towers seen from Church Street near St Paul's cemetery

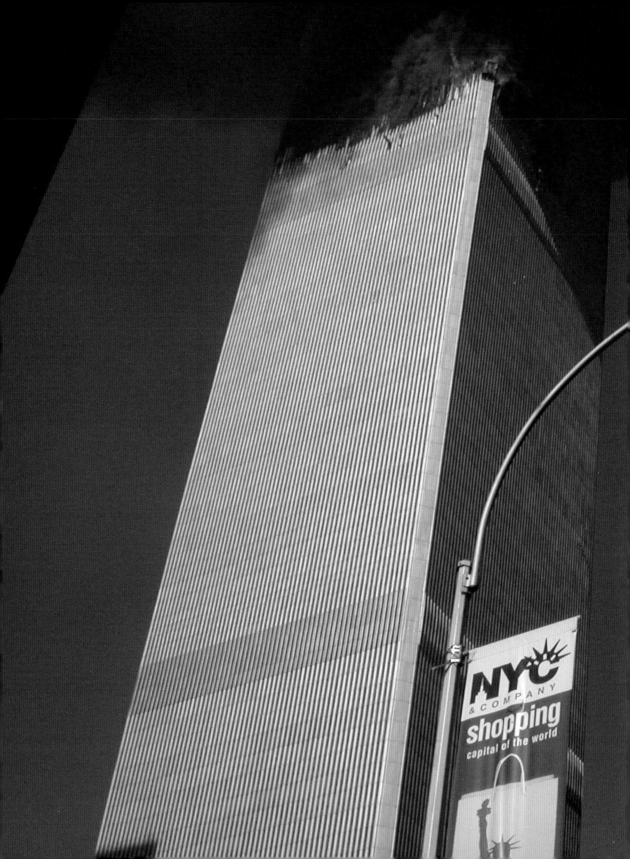

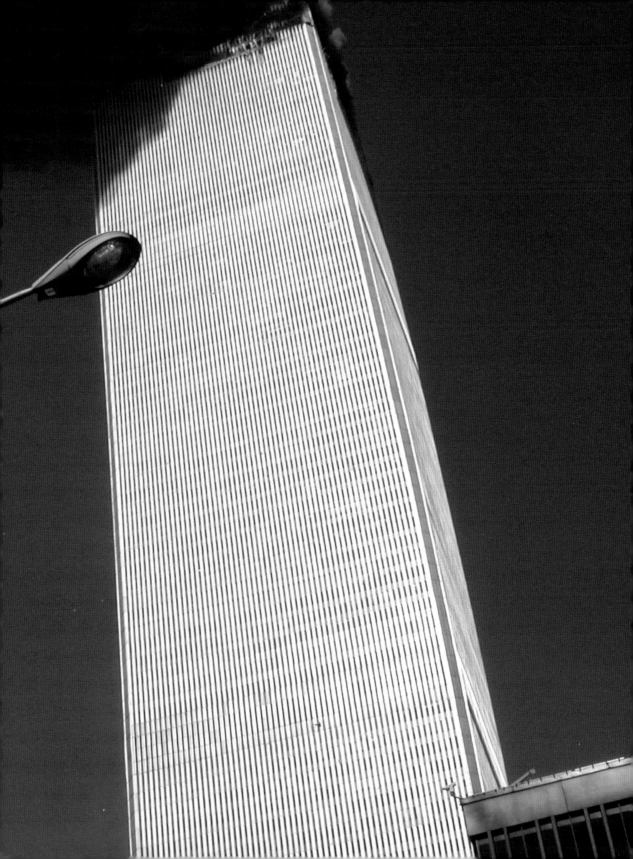

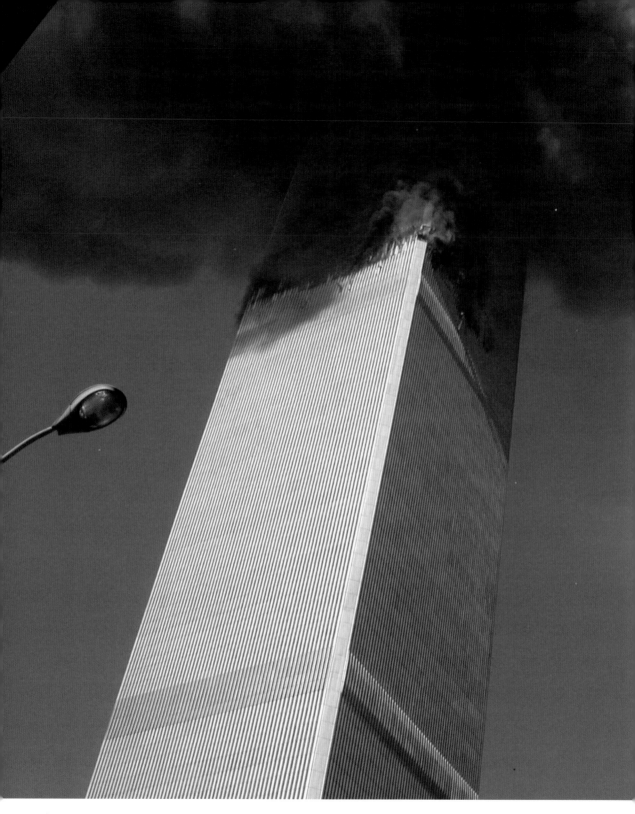

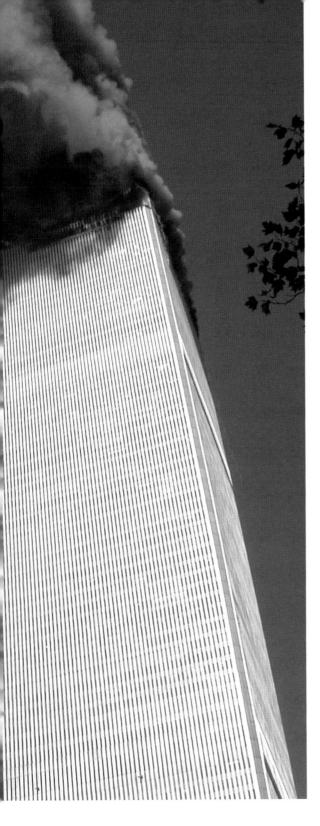

I tried to figure out which floors were burning. I remember shaking my head thinking that the firemen must have seen all of this from the street before going up, and could any of them expect to fight this? I saw someone fall from Tower 1, then another, then I stopped looking up.

I recognized Safwat Wahba who was trying to calm a co-worker. I found out later that Safwat had coaxed her all the way down the stairs and out of the building. Now he was helping her to sit down and gather herself. She was shaken and desperate, as we all were, to contact her family. I handed her my phone.

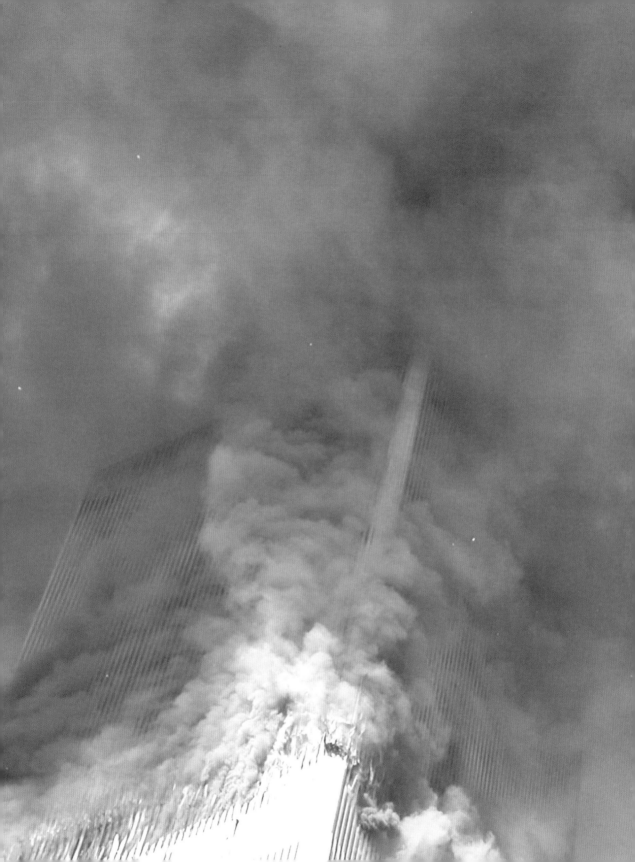

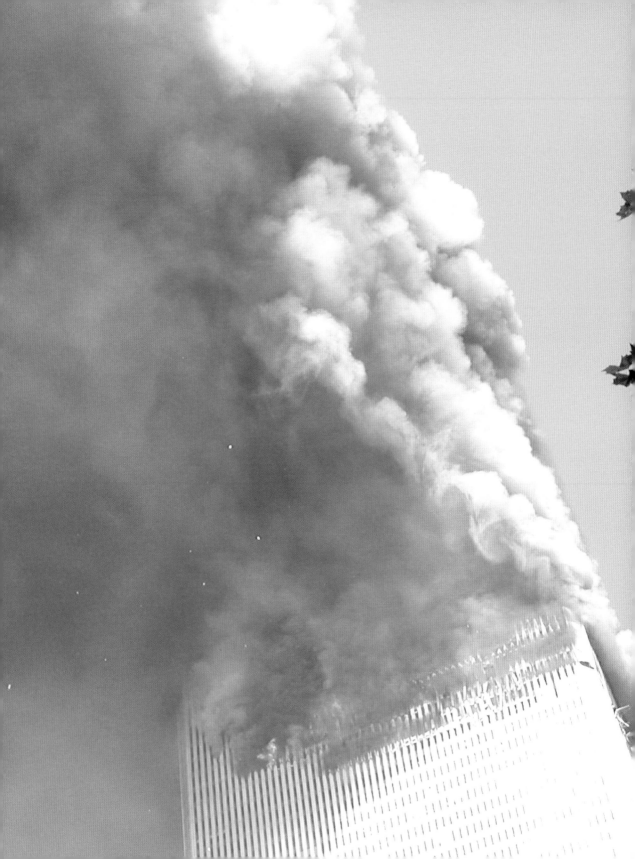

baby's thriving

designs for the face

GIORGIO ARMANI
cosmetics

Giorgio Armani makeup consultation.
and San Francisco (415) 986-1300

network in the Northeast

*verizon*wireless

EMENT

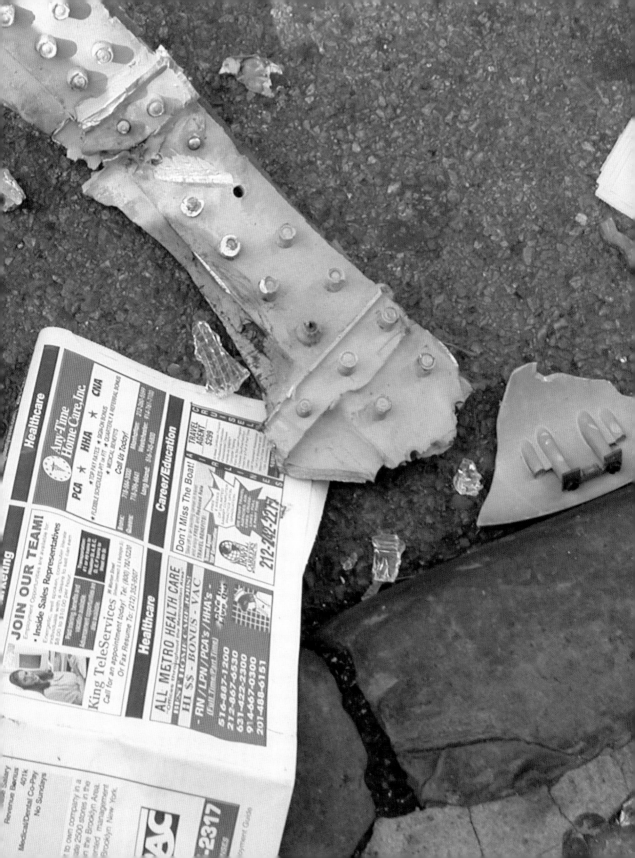

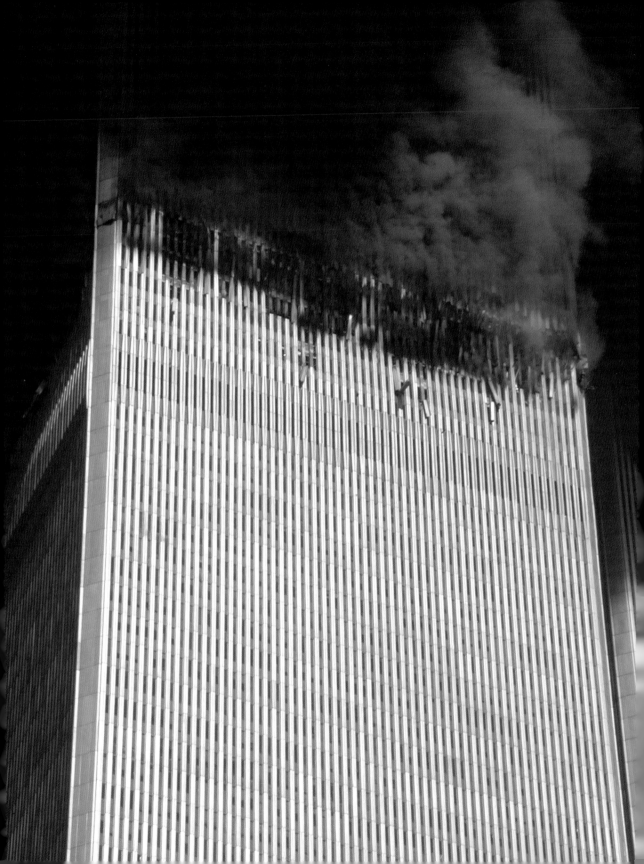

People were just standing around in shock watching the towers burn

She tried to work the keypad but her hands were shaking so much that this only served to make her more agitated. I dialed the number for her, but despite a good signal the call did not go through. Then Safwat tried to call his wife and daughter, and I tried again to call my wife, with no luck. Something on the ground near the curb caught my attention. I stood up and walked over to it. It looked like shrapnel. It was stained with blood. I couldn't help thinking that it must have come from a plane. As I looked around I saw shoes everywhere, and newspapers, and blood. I'm not sure exactly how long I stood there, but when I turned back to my co-workers they were gone.

*Looking up at smoke
plumes while walking
down Broadway*

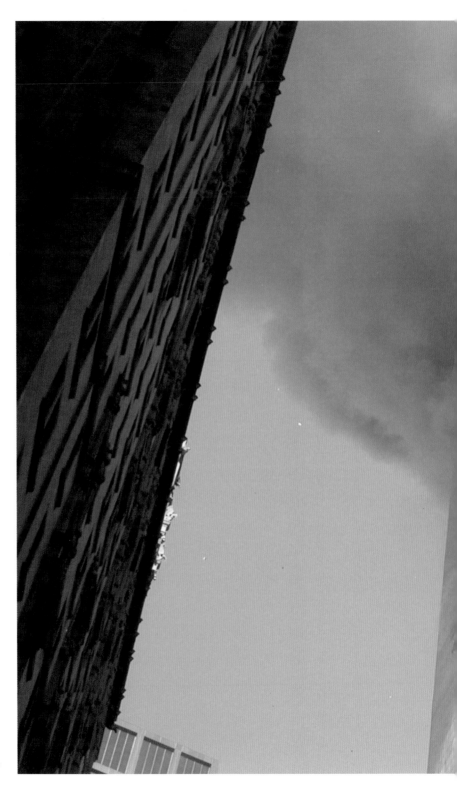

*The last shot I took
before Tower 1 fell*

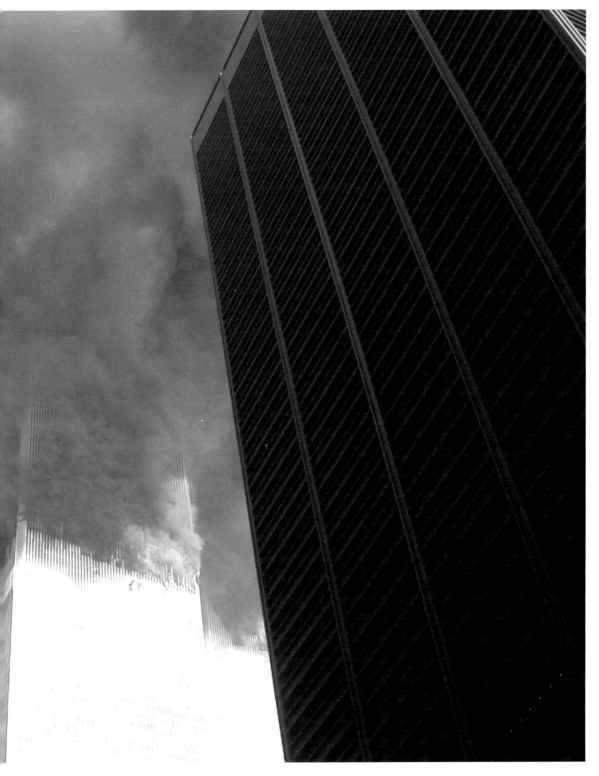

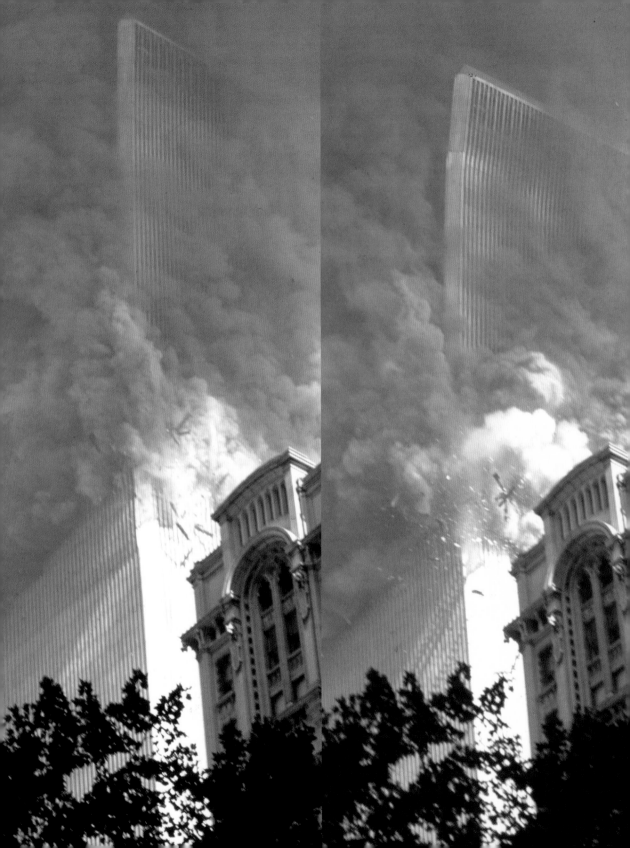

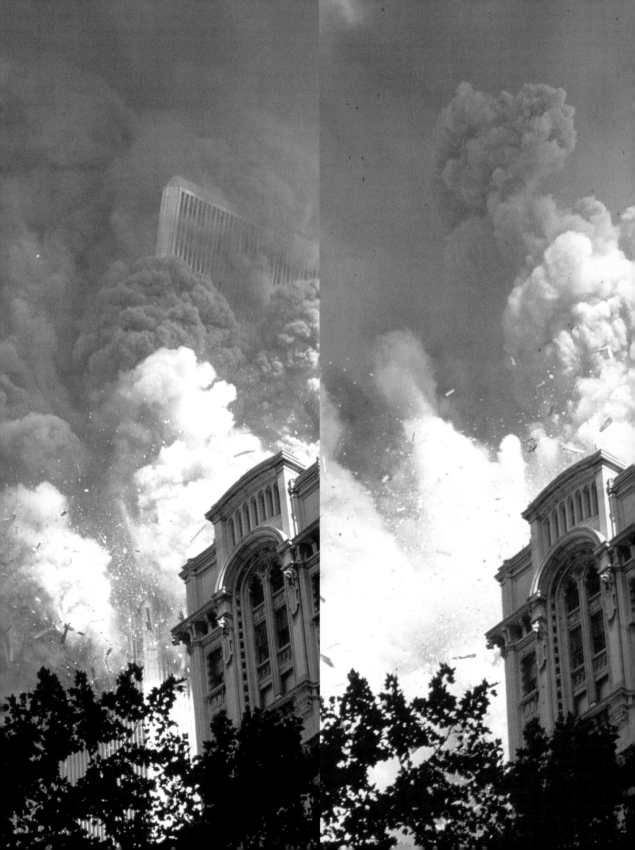

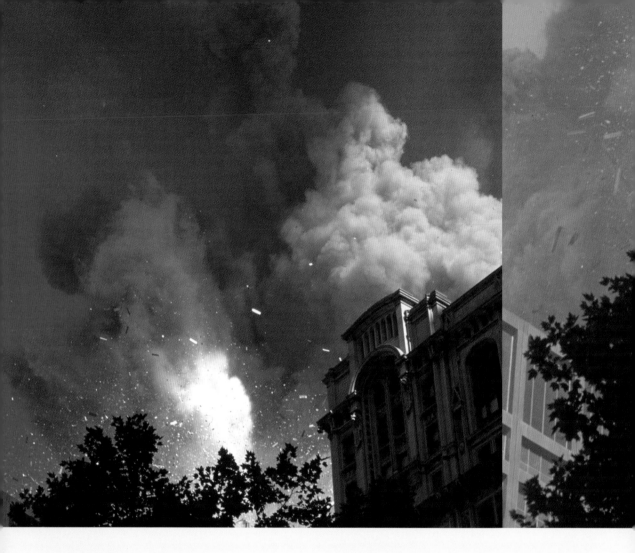

DAVID BRONDOLO'S STORY

On September 11th I was on my usual commute into Penn Station from my home on Long Island. I exited at 33rd Street then headed south down 7th Avenue. I had my camera over my shoulder (I was a photography student and had been in class the night before at the School of Visual Arts). I planned to drop my camera back at my studio, then head to my day job. On the way I saw a group of construction workers looking up and talking excitedly. I didn't make too much of it and walked on a few more blocks to find more people looking up. At this point I stopped and looked up too. Smoke was coming from the towers. From my vantage point it looked like a small fire. Some women began screaming behind me, I took my eyes of the towers to look back towards them, thinking something was coming at me from behind. The women were looking at the towers, I turned back just in time to see the explosion caused by the second plane crashing into Tower 2.

I reached my studio on 19th Street, threw my bag into the freight elevator and headed downtown to photograph what was going on. At the firehouse on 19th Street between 6th and 7th Avenues six or seven firemen were waiting outside. I thought about asking

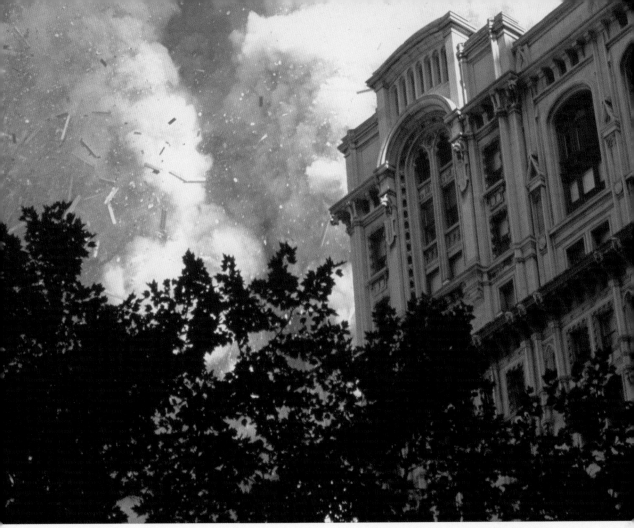

photographs, pages 86-91, by David Brondolo

if I could hitch a ride downtown with them, but then thought better of it. I found out later that 5 of those guys didn't make it out of there. I couldn't get a cab so I took the subway downtown. I told anyone in the car who would listen about what was happening above ground. People were asking if they would still be able to go work in the towers—I told them that they might as well turn around and go back home. They couldn't understand. When the train stopped and the doors opened they all proceeded up the stairs, just any other day.

I still didn't know what exactly had happened, I thought a small plane had hit the building. I contin-ued on southward to see what I could photograph. As I got closer I found that the police were doing a good job with barricades to prevent people getting down town. Someone said "the buildings are going to col-lapse" and people started to run. I thought that was ridiculous, that there was no way such massive build-ings would come down, so I kept going. I slipped past the barricades, sometimes going through the lobbies of buildings and coming out on the other side of the block. At this point I wasn't in fear for my life. I was on a mission, I had to get closer, and I had to get some photographs.

I had lost sense of where I was. In the narrow streets you can't easily see the towers and I hadn't realized how close I had come to them. I found myself just north of the towers. I took some photographs of some debris and parts of the building that were in the street. Eventually I reached Trinity Church. The graveyard was covered with papers and personal belongings, yet I still hadn't put it together in human terms.

I was taking pictures in front of the church when the first tower fell. I heard someone describe it as the sound of dry spaghetti breaking, and that's exactly what it sounded like. I didn't see anything, I only heard the sound because I kept pressing the shutter button and the lens mirror would close, blocking my view through the lens. I didn't really know that I had captured a sequence of images of the towers coming down. A huge billow of dust and debris came racing down the street. It looked like a monster running. I was off to the side so it went right down the street past me. Then it turned the corner and started coming back at me. People were running and I took a few shots of that (this all happened in the space of a moment) until I realized I would soon be engulfed by the smoke.

I ran back to the church. Blocking the doorway was a man with his face against one of the columns as if to protect it from the debris. I grabbed him by the shirt and dragged him through the door into the church. There were people behind the door trying to keep debris from getting through.

After some time inside, someone put a radio up on the dais, and that was when I discovered that both towers and the Pentagon had been hit. It was surreal to be sitting in a church when every thing around you is going to hell, and somebody's praying, and there's a radio on, and people are crying. I was just perplexed, I did not know how to react or what to feel.

Eventually a security guard tried to evacuate us. Most people stayed, but he had a walkie-talkie and

was in contact with the police waiting for us at the back exit, so I went with him. The rear of Trinity Church is set back from the street. To get out we had to go down to the basement, walk through a tunnel underneath the graveyard, and exit through a door in the cobblestone wall. Outside it was dark and eerie, filled with smoke and dust. I had nothing to cover my face. I reached a bus station that was only 25 feet or so from the back door of the church.

I remember thinking two things: that I wished I had my camera out; and that I was probably going to die, right there. I thought my best chance was to go back into the church but I realized I couldn't see the door any more. I yelled to the people around me to come back to the church—two were women carrying their infant babies, I don't know what happened to them. I still couldn't see the door but I made it over to the wall. I was thinking about my children and my wife, and how horrible it would be if this was the place they found my body. I thought my chances of surviving were nil, I thought I was dead.

I managed to find the doorway but it was almost completely dark. Back in the basement I could make out some shapes, but there were several doors and passageways. It was filling up with smoke and I could not recall which way to go. I started to panic. I thought if I didn't find my way back to the stairs that this was it. I turned around and went to the right and found the stairs. As soon as I hit the top step I heard the second tower fall. Large objects were hitting the roof of the church and I was afraid the roof might collapse.

Outside it was so dark it felt like the middle of the night, and though the air was relatively clean inside the church I was worried that the building would fill up with smoke and we wouldn't be able to breathe. Eventually the smoke began to clear, and I went and stood in small vestibule on the north side of the church to see what it looked like outside. That was when I met John Labriola.

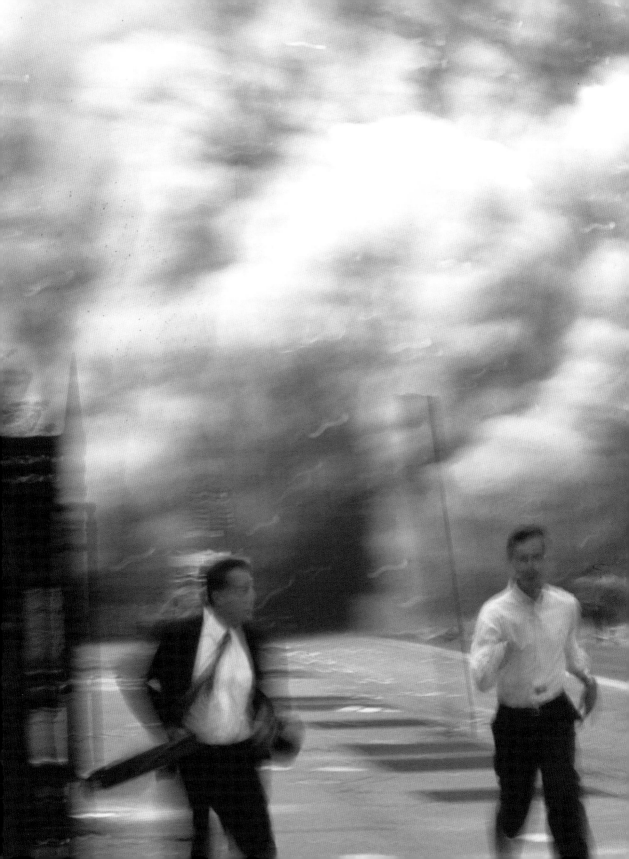

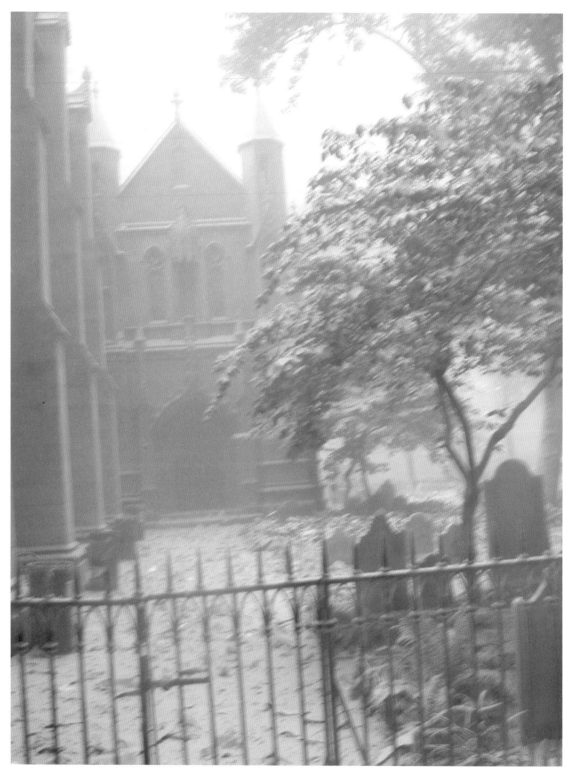

Trinity Church

I needed desperately to get out of there, to get home to my wife. I decided to try and make my way back south and west towards my car. As I neared Wall Street I noticed the doors of Trinity Church were open so I stepped inside. A priest was leading a small group of people in prayer; seconds later, as I knelt to join them, the first building fell.

The stained-glass windows that had been filled with color and light turned inky black. You could feel, as much as hear the building collapse. Debris was hitting the roof of the church. People dove under pews.

When the earth finally stopped moving I went into the vestibule and looked out of the front door. The air had become a solid mass outside, impossible to breath. There were twenty of us inside the church. No one appeared to be hurt. We gathered together and made plans to evacuate.

A maintenance worker, who was on hand suggested that we go to the basement. He and a few others checked it out but found it too choked with smoke and soot. I remembered thinking about the chemical disaster in Bhopal, India. My uncle, Vincent Wilson, worked for Union Carbide back then, he had told me that if the people had only covered their faces with a wet cloth, they might have survived. I found myself talking out loud that we should search the church, find towels and water to make up wet cloths for people inside and out, should we need to leave the protection of the church.

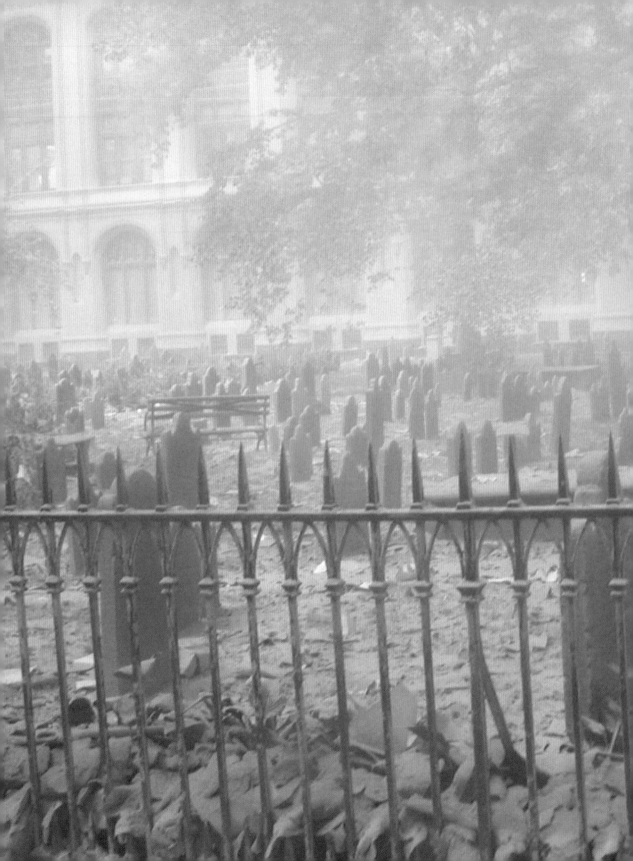

I took refuge in Trinity Church and captured this image of the graveyard before Tower 2 fell.

JOHN FISHER'S STORY, told by Ed Rolly

John Fisher, Medal of Honor (Civilian)
Description of Extraordinary Act/Contribution

On September 11, 2002 at 8:46 am World Trade Center One was struck by the first plane, and Mr. John Fisher was a passenger in a Port Authority Vehicle in the basement of World Trade Center One. After the impact the vehicle proceeded to the exit ramp, the rolling door opened and the vehicle proceeded up the ramp. There were great amounts of debris and shrapnel plummeting down all around the vehicle and the exit ramp area.

When the falling debris let up for a minute Mr. Fisher stepped out of the vehicle and analyzed the situation, realized that it was a terrorist attack and stated that he wanted to go back into the building to go to the Operations Center to make sure everything was functioning correctly.

The guard was instructed to lower the Delta barrier. The vehicle proceeded out the exit, then South on West Street, made a "U" turn into World Trade Center One VIP driveway where Mr. Fisher got out of the vehicle, ran between the wounded bodies and through the falling debris and proceeded to enter the lobby of World Trade Center One.

From there Mr. Fisher went directly into World Trade Center Two and proceeded to the Operations Control Center in the basement. Once inside of the Operations Control Center Mr. Fisher proceeded to operate the closed Circuit Television cameras, the intercom system and the public address system in the struck building directing staff and tenants off of their floors and out of building one.

When World Trade Center Two was struck by the second plane Mr. Fisher stayed by his post again operating the closed Circuit Television cameras, the intercom system and the public address system in the second struck building directing staff and tenants off of their floors and out of both buildings. Mr. Fisher died while helping others when World Trade Center two came down.

In all 74 people working for the Port Authority died on 9/11; 37 Port Authority Police and 37 Civilians. The few with whom I've worked with directly in the past include Doug Karpalof who headed up WTC security.

I had helped support Doug's pride and joy, the Access Control, and Security Systems at the World Trade Center in 2000 but aside from a few meetings I really didn't know him that well. John Fisher on the other hand was Civilian Medal of Honor; *and* John Fisher.

On the morning of 9/11/01, I just finished breakfast with my wife in the lobby of Two WTC and dropped her off for a class on the 61st floor. I went to my office on 71 and started finishing up some paperwork. I was supposed to go to Staten Island with John Fisher that morning to scope out a project. John was busting my chops trying to get me to leave right away as he had something to do that afternoon. I finished my tasks, and we took the elevator to the lobby and then a basement elevator in Two WTC to the B3 level.

I picked up a company vehicle, a marked jeep, I gave the automotive-use form to John to fill in and we started to leave the parking lot. Just as we got to the yellow level, level B1 under One WTC, John loudly asked what was that. I didn't hear or notice a thing. I was busy getting the various electronic identification devices ready so that we could leave the building. I continued driving and when we got half way up the ramp to ground level the car started to get pummeled with debris. I pulled up further and we could see that the guard was looking up at One WTC. I went to get out of the vehicle, but John grabbed my arm to restrain me, he said that we should wait to get out of the car until the shrapnel stopped falling.

A few minutes later the falling debris let up and we got out of the jeep. As soon as we looked up, without even saying it, we both knew that the building had been hit by terrorists and that they must have smuggled a bomb in, as nothing in the building could have blown up with explosive force like that—we didn't know about the plane yet.

We agreed that it would take about six months to repair the damage and reopen the tower. Then John said that we had to go back into the building. I told him no because the terrorists had won and that we had to start at ground zero again; we had to get out of the way to let the emergency services people do their job. I also told John that we should go to New Jersey to set up a telephone command center. He got angry with

me and emphatically said no that he had to go back in to the command center to see how it was functioning.

I told him to get in the car and that I would drive him around to the entrance. John got in to the jeep and I instructed the guard to lower the barrier, which he did. As soon as I drove around the semi-circle exit driveway we could see wounded bodies everywhere and people trying to tend to them. People were all running uptown away from the WTC on West Street. I then exited the driveway heading downtown. I made an illegal "U" turn between some vent shafts though some traffic cones and dropped John off on the sidewalk in front of the VIP driveway. I watched him as he got out of the Jeep with his leather briefcase and ran into the building. I did wonder why the lobby was so devastated when the explosion was up so high, but I chalked it up to falling debris breaking the glass awning.

I took the Jeep and headed for the Holland Tunnel intending to go to the Port Authority Technical Center to help out with a command center. I called John on his cell phone and left him a message to get out of the building. Just as I arrived at the Technical Center, Two WTC was struck by the second plane. The PA staff were hysterical crying, hanging on to each other and falling on the ground in disbelief and torment.

I went inside to my wife's office and found out that my wife's boss was also at the WTCF that morning. I then told the NJ staff to go home and I gave the NY staff goal oriented work to do. I called my daughters school and told them to tell my daughter that Pat and I were OK. They refused, and I told the lady that she had to tell my daughter that we were OK, as she knew that we were both in the building. I called John Fisher's cell phone again and left a message for him to get out of the building. Then I fielded all the calls from various families calling in about their loved ones.

Then two staff came running in to tell me that Two WTC had come down. I went out in disbelief, and could not believe what I was seeing. I went back in and continued to field the phones and help the staff cope. Then they ran in again to tell me that One WTC had come down too. I didn't know where Pat was and had a hard time keeping it together for the staff. I stayed a while and helped the staff to cope. The phones totally failed and I decided to go home with

the Jeep and to leave Pat's car at the tech center for her use when she got there later in the day. (The staff now refer to me as the rock and so does Pat's family as I walked them through the disaster in a positive light telling about where Pat would be each step of the way.) At home I fielded phone calls, made calls and tried to keep busy. At about 1 PM I got a call from a woman telling me that my Pat was with the woman's husband in a bar in the village. I thanked her and hung up. Then I called her back to really thank her and I broke down. Two neighbors came to help out and one of them was just looking for a beer, and boy did he have the wrong house. So as I was gently pushing them out the door another neighbor had picked up Danielle, my daughter and was dropping her off. She went to pieces immediately seeing the official jeep in the driveway and thinking that the strange men in the door were police coming to tell her that Pat and I were dead.

I calmed her down and got the two neighbors out of the house. Then the phone rang and the caller ID indicated that it was a bar in the village, but we couldn't hear anything on the first two calls but my daughter was shouting into the phone: Mommy I know that it's you…" Finally on the third call we established communication and all was well. John Fisher's sister had gotten my number from somewhere and she called me and wanted to know honestly what John's chances were and I told her the truth that I didn't know. But on the Wednesday when I spoke with the last guy to see John alive and he described what had transpired, I knew that he didn't make it and I told his sister my fears, which she appreciated. (Ray was with John in the command center where John was helping man the emergency-communication equipment. Ray got sent out to Five WTC to check power when two came down.)

When Pat got home that night around 8:30 PM, she brought home some NY workers to sleep over and one guy that we drove home to his family. Pat and I went to Newark International Airport and walked John's family and other families through the benefit process, to make sure that they got there due.

At the memorial service for John, I told his oldest daughter (John had seven children) that I had known John since 1990 and that he was always a pain in my behind, and she started crying and hugging me saying that he was always a pain in hers too.

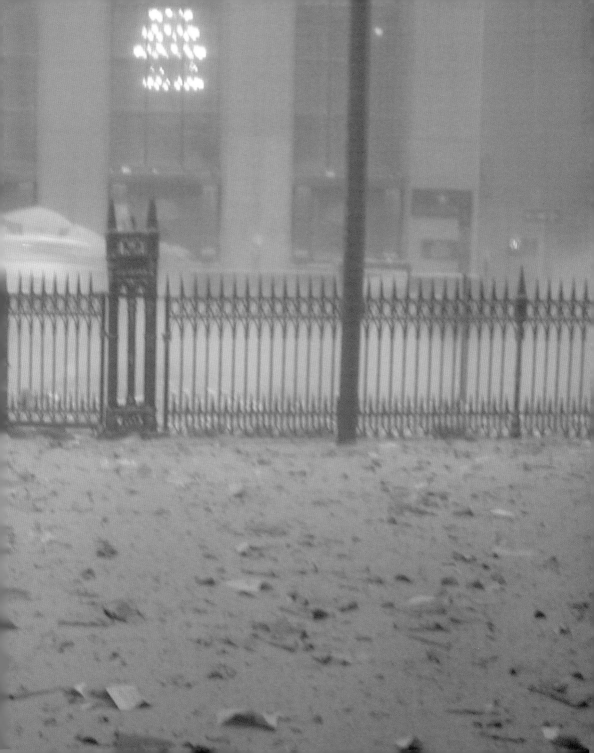

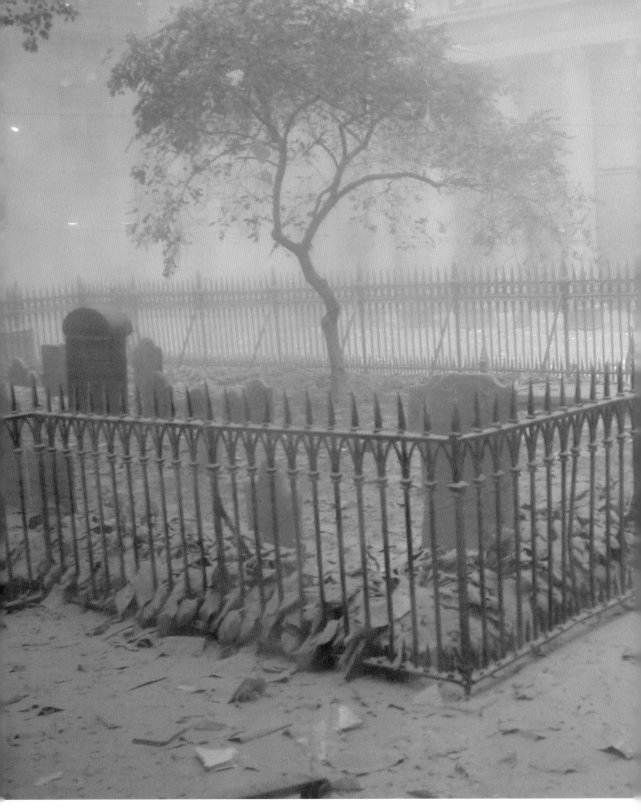

The roof of the church had held. We were in a pocket of relatively clean air. Someone found a radio, and positioned it on the pulpit, hoping for some news that might help us determine what was the best thing to do.

Then, miraculously, my cell phone rang. It was my mother-in-law calling from Holland. This was the first time my cell phone had worked since the disaster. She told me she had spoken with my mom who had given her my cell phone number and that she hadn't able to reach my wife, Jenny, at her office in midtown. I asked her to get word to my mom that I was all right and to keep trying Jen. I hung up, tried again to reach Jenny, but still couldn't call out.

I went to a north-facing exit into a vestibule from where I could see into the graveyard. I was trying to determine it was safe enough outside to leave the protection of the church. It was growing light enough outside to just make out the shapes of other buildings. The sun was trying to break through the smoke and ashes, creating an apocalyptic but eerily beautiful scene. Mesmerized, I fired off frame after frame forgetting momentarily why I had gone outside in the first place. I headed back inside, thinking that if the dust continued to settle, it would be clear enough for us to leave within ten minutes or so. I was about to share my opinion with the others inside the church, when the second building fell. There was blackness again, this time larger objects were hitting the roof, which again held fast. There was a lot of uncertainty about whether it was safer to stay in the church or take our chances outside. From the radio we knew that both towers had fallen, but to what extent we could not guess.

While I continued to search the church for more rags, someone had found a telephone that was working. I waited my turn and was able to get a call to my wife in midtown. She was devastated. She knew I was in the building that day and had seen both towers collapse from a TV in her office on 45th street. She told me that my brother-in-law was on his way to get her and take her to his apartment in the West Village. I promised to meet her there. We chose to wait it out. 40 minutes or so later it was again clear enough to see across the street. We all said our goodbyes to each other and in groups of two and three headed out to find a way home.

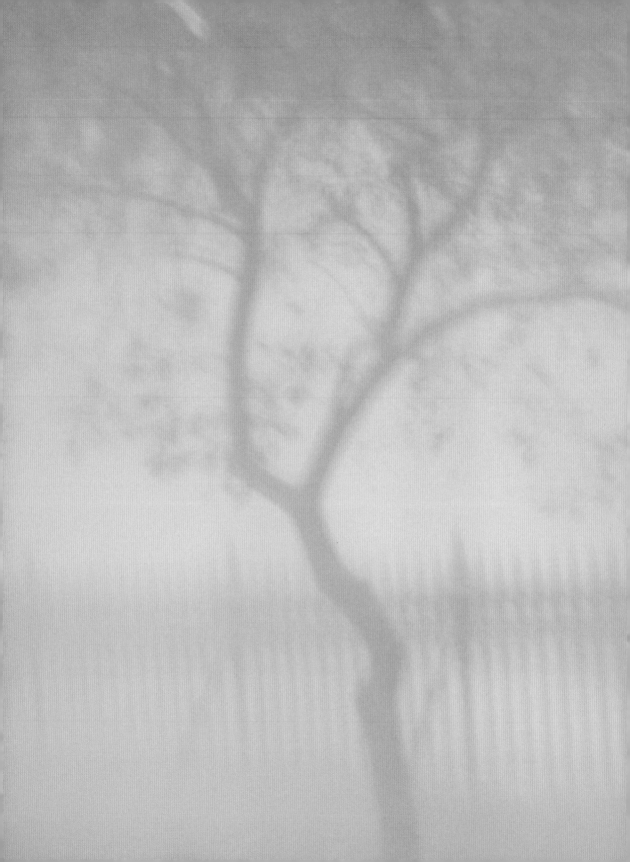

The Tree

It was a tree.
I could see it through the cloud of dust and ash
Light played with its branches
And touched briefly its trunk
Then the ash cloud swallowed it again
But it was a stubborn tree
And showed itself again
Exquisitely beautiful
Despite the context
Despite the ash
It was pure
It was beautiful
It gave me hope

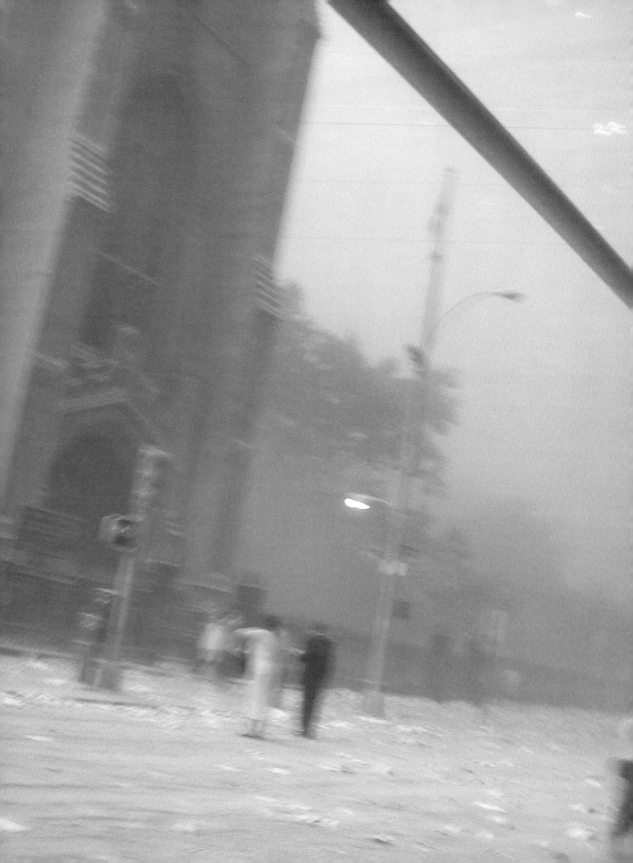

Walking Away

Outside it was a mess. Winds would whip through the streets causing temporary whiteouts and blotting out the sun. I remember thinking that they must have been caused by the backdraft from the fire. Emergency vehicles caused their own whiteouts and we would have to cover our faces as they went by. There were three of us in my group, headed south down Broadway, then east on Exchange Place. At South William. I took a series of photographs of workers leaving the area, and of a group of firefighters walking in. Though the ground was still covered in ashes the air at this point was relatively clear; we felt were far enough east now and turned north on South William. Crossing back over Wall Street, I peered west through the smoke and ashes barely able to make out the spire of Trinity church in the distance. As we continued north, I stopped at intervals to look west, taking shots at vantage points from which I knew I should have seen the towers. I was inside when they collapsed, I guess it just didn't make sense to me that the buildings were completely down. We made our way over to where Water Street crossed under The Brooklyn Bridge. Thousands of pedestrians had lined up—some were ascending the stairs that led to the pedestrian walkway while others headed up vehicular ramp that led across the bridge to the Brooklyn side.

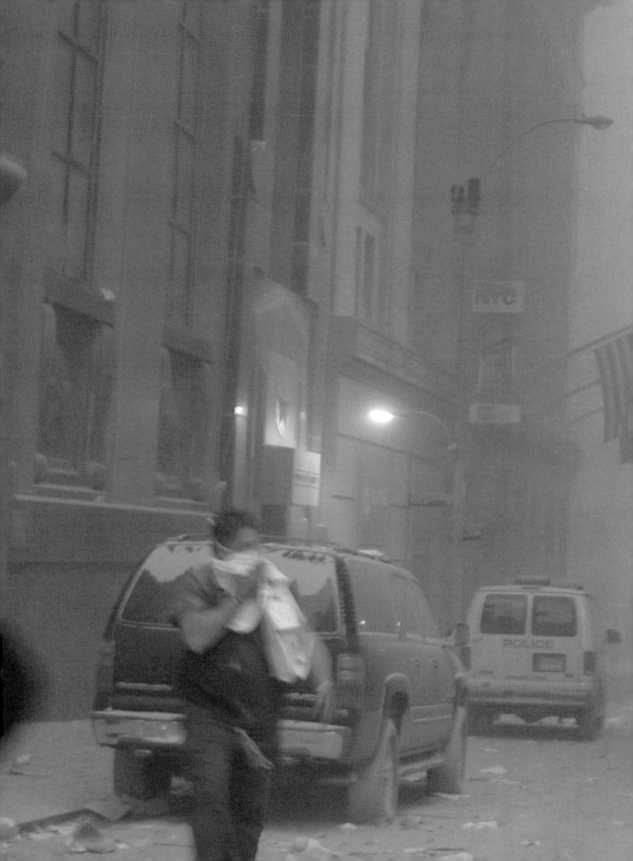

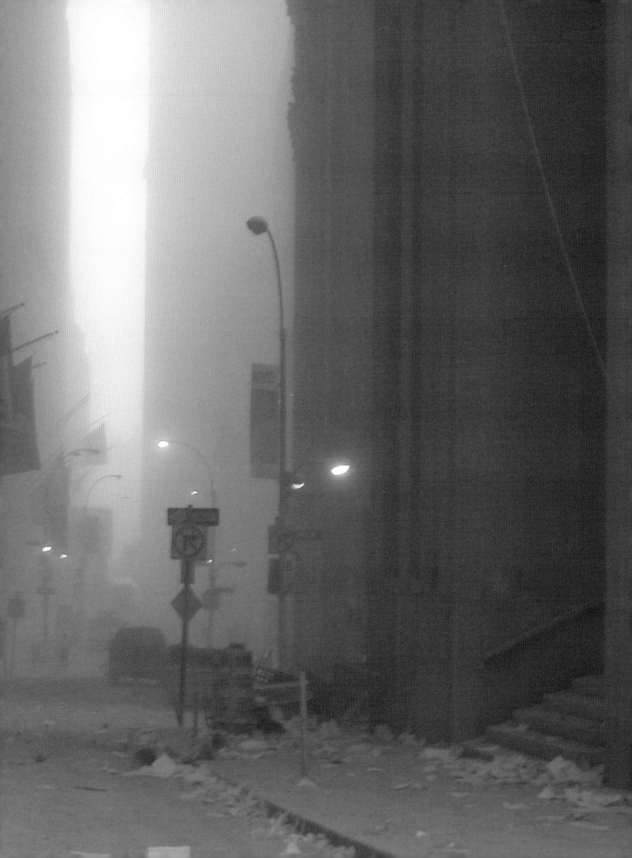

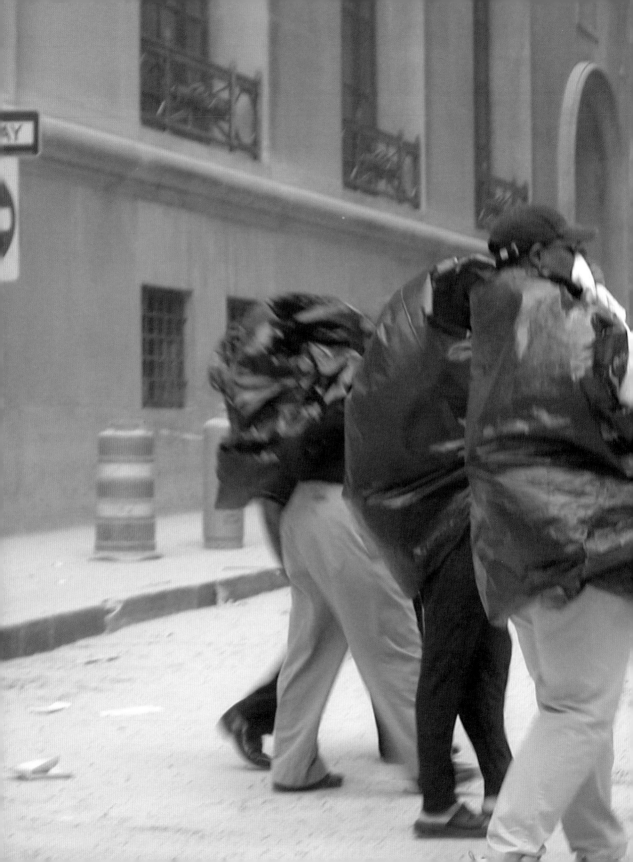

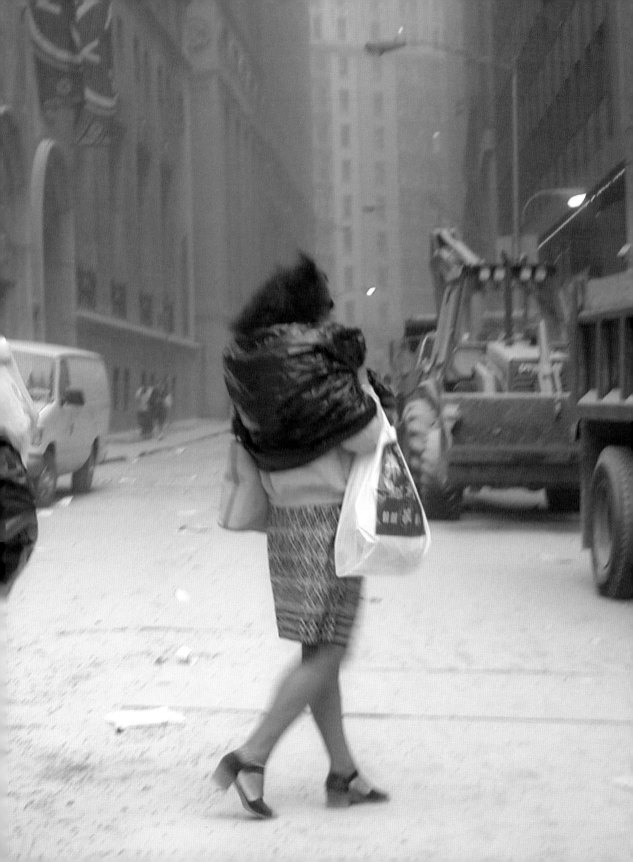

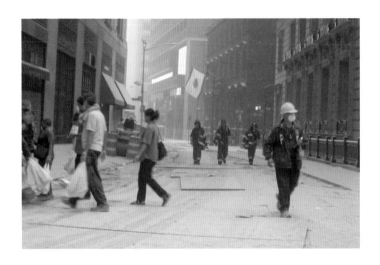

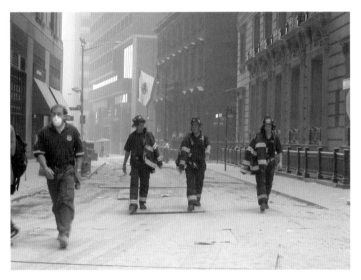

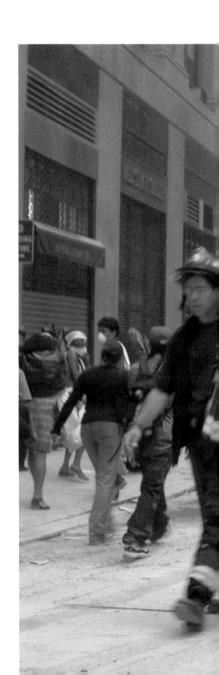

Fireman arriving at a scene of devastation.

Here, one of our group left us for Brooklyn en route to his home in Staten Island. As he climbed the stairs I realized I couldn't remember if I had asked his name. The remaining two of us continued north on St. James and then Mott Street into China Town, crossing Houston Into Soho. All along the way people gathered in disbelief warily looking south and west. Radios and portable TVs drew large crowds. As I got further north I could see the plume of smoke and ash rising above lower Manhattan, trailing east towards Brooklyn. I discovered that my companion's name was David Brondolo, a student of photography at the School of Visual Arts. That morning he had been on his way to his day job on 25th street when the first tower was hit. He had actually made it to the lobby of his work place, and instead turned around and headed

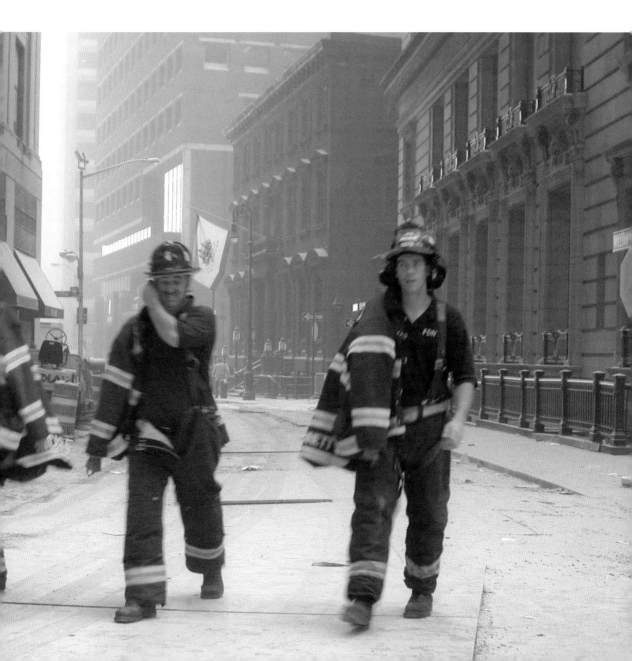

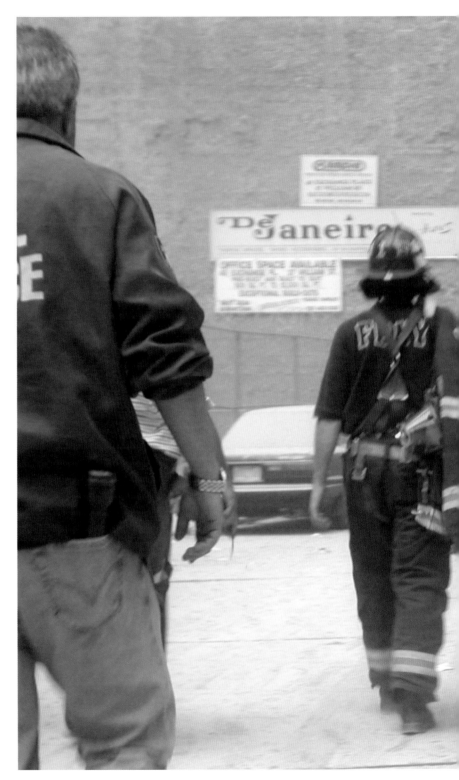

*Firemen walking towards
ground zero*

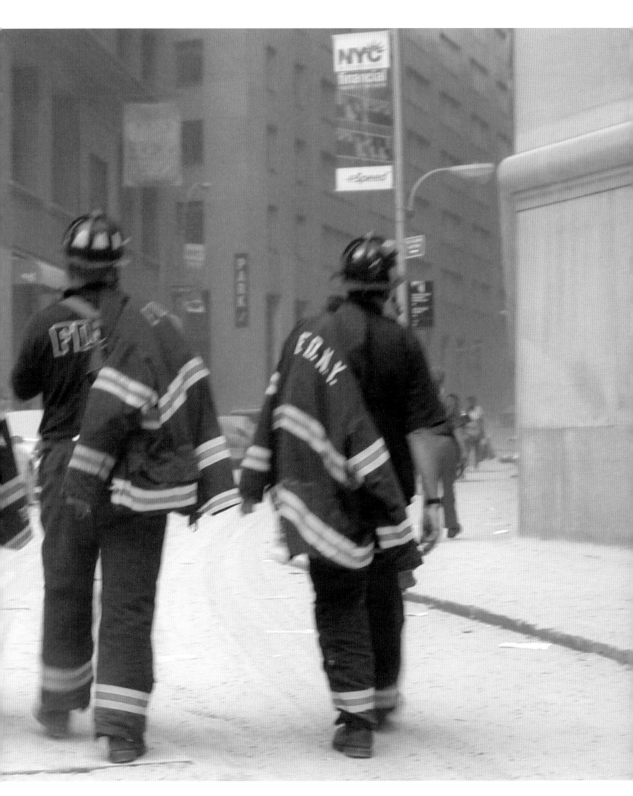

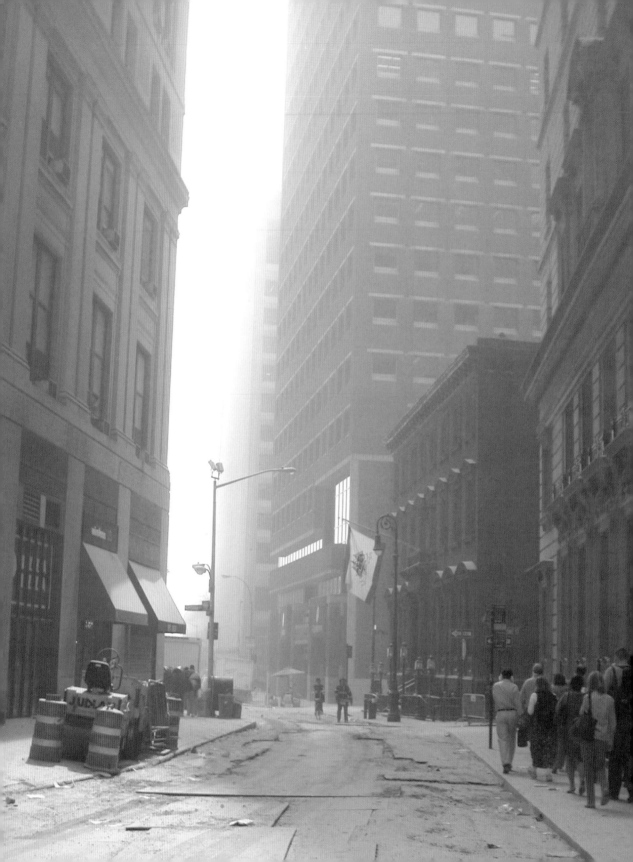

south with his camera towards the World Financial Center. I asked him if he was studying photojournalism, he said no, commercial photography. I remember joking that maybe he should reconsider careers because he sure acted like a photojournalist. He was heading back to work, we exchanged email addresses and said goodbye to each other in Soho near Broadway. As a continued alone, heading north and west, I overheard someone talking on a cell phone, telling an unseen person that no one above the 60th floor could have gotten out of there. I stopped, and told him that it wasn't true, that I had walked down from 71. He called after me, "Thank you sir, thank you". I just kept walking. I finally made my way to my sister's house where my wife fell into my arms. I can't imagine what she felt like not knowing. I can't imagine what its like for thousands of others who's loved ones didn't get home. My heart breaks for them.

Walking home looking east.

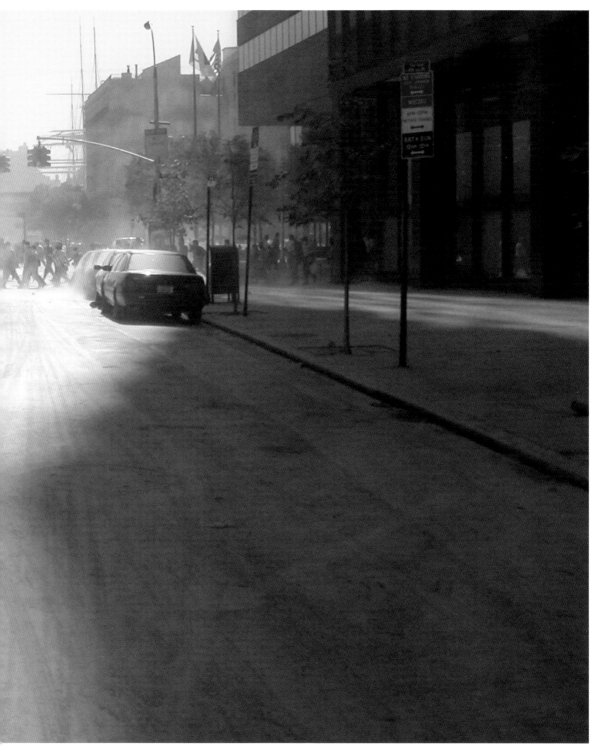

Looking east down Maiden Lane.

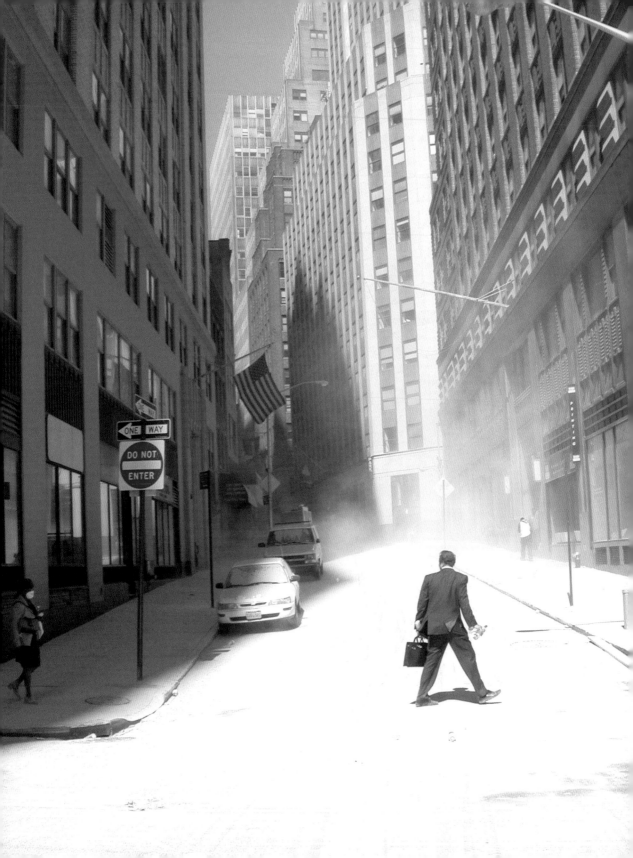

The Way Home

I was a mess. No one knew how toxic the dust I was covered in was, I had to get it off my skin. I reluctantly let go of Jenny, stripped, quarantined my clothing in a plastic bag, showered, and scrubbed my skin till it ached. I borrowed some clothes, and emerged looking something between my old self and Jenny's brother, Michael. Back in the living room I took hold of Jenny and wouldn't let go. I won't forget the look in her eyes. As I unfolded more details of the ordeal, I noticed her intense scrutiny of me as she searched for signs of emotional or physical damage.

Other friends came by; they were stranded in the city, unable to get home to their families. We following the breaking news together, trying to piece together bits of information, while trying to work out ways to help get them home. We watched the news in disbelief. Since I was in the building when the planes hit, and in Trinity Church when they collapsed, I wasn't prepared for the footage that was repeated over and over on TV. It didn't make sense, it wasn't real to me.

For a while we sat in the apartment and collectively worried: who did we know that worked or lived near the towers? Who hadn't we heard from? Was our air safe? Were we still under attack? Would the water supply be next? What about the food supply? Like New Yorkers all over the city, we made plans and took action, we ran to the grocer to stock up on food, water and emergency supplies.

Afterwards we huddled together in the living room devouring junk food, taking solace in each other's company and the softness of the furniture. But it was hard to feel any real comfort while an army of rescue workers battled with the flames and pile or while thousands of family members of the victims still waited for a homecoming that might never come.

Emotionally and physically drained, Jenny and I finally left my sister's place and headed further north, towards our apartment on East 90th Street. Some subways were reported working but after everything that had happened we couldn't face going underground. Taxis and buses were non-existent, so we had a choice:

walk the 90+ blocks or accept my brother-in-law's offer of a drive home.

It was an eerie scene—piercing blue sky, plume of smoke over lower Manhattan, drifting eastward toward Brooklyn, the smell of burning dust, metal and plastic in the air. We picked our way north and then east as we drove through a city that was obviously in shock. Pedestrians and motor vehicles alike moved in a world where the usual rules were temporarily suspended. No one stopped for traffic lights, no one reacted to vehicles bearing down on them. People were indifferent to horns and sirens and even their own surprise upon finding themselves in the middle of the street staring blankly into the grill of my brother-in-laws SUV. It was surreal, like watching television with the sound switched off. Everyone was feeling numb, the only thing that got anyone's full attention was the sound of fighter jets overhead. It was such a relief to be back, finally, in our own space.

Despite the familiar surroundings we were both shaken and probably in shock. I still wouldn't let Jenny out of my arms. I repeatedly assured her that I was alright and promised her that everything was going to be alright. I honestly felt OK, I didn't think I was in shock. However, there was always the possibility that I was as oblivious to my own condition as the shell-shocked people we passed in the street on our way home.

While Jenny worried over me I worried about Jenny. What could she be feeling? During my escape, she and her colleagues had watched the towers fall, on TV in her office on 45th Street. I keep wondering how I would have been if our roles had been reversed? In many ways what Jen went through was much harder. I was aware how grave the situation was but I knew I was OK. How impossibly difficult and frustrating to watch and wait for a homecoming that might never come? For more than four hours she had to live with the possibility that I was dead. Because I was in the building during the attack, ninety nine percent of people ask, how's John doing? Very few ask me about Jen.

On The Web

Later that day Michael got hold of my camera and was paging through the images I had taken during my escape and walk north. I began looking through them too. Although I was there, and had taken the pictures, I was fascinated to be seeing them for the first time. I loaded the images onto my laptop so it would be easier for everyone to see, and then began the narration to the images that, by now, I have repeated hundreds of times. What a strange feeling it was, hearing myself describe each frame, feeling as if I was as much audience as narrator. Some images told a nearly complete story in themselves, some would reveal themselves over time. Many others will remain a mystery, especially to me. By the end of the day I had formatted the images into thumbnails, created a web page and uploaded the files to Michael's web site. When I posted the images to the Internet and sent a few emails directing folks to them it seemed the most natural thing to do. Neither of us was prepared for what would follow.

Photographers were irresistibly drawn to ground zero, but my photographs were taken from a different perspective. I certainly took the time to take the photos you see here, but I had been inside when the impact came, I had taken the long journey down the stairs with the other survivors and my driving force was to get out of there, to survive the day, to find my wife, to go home. Like all of us, when I finally made it home, I called my friends, my family, and colleagues. I wrote email after email. I retold my story countless times. It seemed incredible to me that mine were the only known surviving still photos to have been taken inside the buildings before the collapse. I didn't have a clear idea about what to do with the images I had from that day (beyond handing them over to the Police and Fire command). It was certainly clear that the world wanted to see them, and I wanted to share them.

Within hours of posting the images on the web people began calling and sending me emails. My brother-in law, Michael, called to tell me that his industrial strength servers, designed to serve up images simultaneously to thousands of active users, was straining to keep up and had to be taken offline. Again, we were contacted by people who wanted to know why the images were no longer online, telling us loud and clear that they wanted them back. Attempts at reducing image size and using another server were of little help; it was like a brush fire, if I had left the images up, Michael's e-business would have been brought to its knees. I had no choice but to keep the images down. At the same time I was being bombarded with a flood of inquiries, and requests to use the images by the media.

By now I hadn't slept in two days. Most inquiries were polite but as time went on, requests became increasingly insistent and desperate. At some point I was so exhausted that I began to out send cut-and-paste emails from previous communications in order to keep up with the flood of questions. How many ways can you say the same thing? How many times can you relive the event without losing your mind? It was like repeating a word over and over until the meaning is lost. This dilemma led ultimately to the decision to consolidate my memories of that day and post my story on the web along side my photographs already being accessed by the public.

I didn't foresee the magnitude of this decision, or the immediacy of the internet, how quickly it creates communities as it makes writers and publishers of us all. I expected the press to call on me—they were desperate for images and stories from inside the towers—but I wasn't prepared for half the world to contact me via email. All these people were looking for a way to connect to the event, to find a human scale amidst the monumental proportions of the disaster. Some journalists seemed disappointed that my images were not sensational enough, to them the people looked too calm, they did not appear to be terrorized; to them these pictures didn't express the stories they wanted to tell. I felt the images showed just how much selflessness and grace people were capable of: the way people treated one another in the stairwell was a story that deserved to be told.

Ordinary people from all over the world began emailing me, wishing me well. Telling me what they were doing that day and how they had been feeling since. It was extraordinary. In a real sense the emails were not written to me, but to everyone in New York and in America. These images tell a story I could never hope to write. I have been their caretaker for two years now, it's time they were delivered.

The Emails (a selection)

From: Hilton Neha
Sent: Thursday, September 12, 2002 2:50 AM
To: John Labriola
Subject: Hello from Australia

Hi John so glad to hear your OK after reading your story. I know it must be a sad time for you reliving that horrible day. Last nite for the anniversary we lite two candles with our 9 year daughter,one for the mums sisters and daughters who didn't come home and the other for the dads, brothers and sons. We watch the documentary by two french brothers of their time with the fire brigade and I just kept thinking I hope they didn't have time to realise what was happening as those building come down and the terror that the people on the planes faced makes my heart hurt. I just wanted you to know that our small family here in Sydney sends you and your family a hug and to let you know we just wished we could have done something to help. Quiet a few firefighters have come over for holidays but we wonder how the average worker is coping.
All our love

Donna Neha and family

From: Linda Goin
Sent: Friday, September 14, 2001 12:21 PM
To: John Labriola
Subject: Thank you

Thank you for your story and for your photos. It's so heartening to hear from someone who was there, someone who made it to safety.
Many long years to come for you and yours.
My regards,

Linda Goin

From: Michele Gran
Sent: Friday, September 14, 2001 4:49 PM
To: John Labriola
Subject: Thank you

Thank you so very much for sharing these images and your words with the world. I saw your interview this morning on ABC. My heart broke. God bless you eternally.

Michele Gran

From: Tim.Pirtle
Sent: Saturday, September 15, 2001 5:59 PM
To: John Labriola
Subject: I'm stunned...

.....after reading your story......I am a Fire Captain in the state of
Washington...I have been to the WTC and I have taken firefighting classes
offered by FDNY in years past. Those guys you saw go by you in the
stairwell...they are the best firefighters in the world...and they knew what
was probably going to happen.....it was a "JOB" as they call it. And it
will be known as "the greatest JOB ever"....great story....Thank you.

From: J.A. Lyons
Sent: Sunday, September 16, 2001 12:45 AM
To: John Labriola
Subject: Your pictures

John --
Thank you for sharing your pictures of the World Trade Center Tragedy with
the world.As I looked at them it occurred to me that there are some firemen
and other rescuers and police families who might want to see them, as there
are a number of men in those pictures that I would assume perished in the
collapse.

Even in several of the staircase ones their numbers are visible (although very
blurred) on their helmets. Those men's families may want to see them as a
memorial of the bravery and duty that these men performed for the people of
New York. It breaks my heart.

There are a number of other shots where the officers in the building
and outside are more clearly identifiable, and I would hope that you
have taken the step of passing them along to the appropriate people.

These men are so ordinary -- and so magnificent.We weep with you all.

Janice Lyons

From: Gerald Gretsch
Sent: Sunday, September 16, 2001 1:09 PM
To: John Labriola
Subject:

I want to thank you for sharing your experience, your thoughts and spectacular
pictures with America. I caught a segment of your moving, emotional interview
on television last week and appreciated very much

witnessing, through your photographs, your personal journey from Armageddon to safety, showing the effects of the desolation and of hope, with the help of fellow man and God. I share your good feelings and relief in your and others' survival, but also the sorrow and disbelief in the tragedy that has come to so many.

Thank you again for your witness.. God Bless us all.

From: Jeffrey and Kay Crane
Sent: Tuesday, September 18, 2001 2:21 PM
To: John Labriola
Subject:

Dear John,
I just read your personal story and have been deeply touched. Thank you for sharing your story. I will be keeping you, your family, and all of the victims of this terrible tragedy in my thoughts and prayers.
May God provide you with strength and courage to cope with the all that you have experienced and witnessed. Wishing you the peace, hope and love of Christ Jesus,
Kay Crane
Conyers, GA

From: Linda Jarriel
Sent: Thursday, September 20, 2001 8:30 AM
To: John Labriola
Subject: God bless you!

John,
I just happened upon your story. I don't know anyone that works in NY, but I am one of the millions of Americans that have watched and cried and marveled at all the heroes and cringed at the hatred that could cause such a thing to happen. I'll keep you in my prayers that you can find something positive out of this. I hope you have found your co-workers safe. I'm so happy that your wife doesn't have to wonder if you are buried under all that rubble. It's hard to tell from pictures just how wide the path of the damage is. I live in Charleston, SC, where hurricane Hugo struck in September of 1989. We had destruction for 100 miles north and west of us. An entire forest was destroyed, homes and businesses disappeared under trees and power lines or were carried away by the wind and waves. I remember getting water from the National Guard, who had set up camp in the parking lot at the Mall, which was damaged. I remember people being forbidden to return to the islands where their homes used to be. I remember not having electricity for 2 weeks. I remember the trucks from the electric companies from states all over the country. I remember applauding the men who worked 12 hour shifts when they

From: Robert Himrod & Family
Sent: Monday, October 01, 2001 12:30 AM
To: John Labriola
Subject: Photo of Firefighter Mike Kehoe

Dear Mr. Labriola,
I'm so thankful that you and others were able to escape that horrific
attack. My family and I are sadden at the terrible loss of innocent life. I
was very moved by the photo you took of Firefighter Mike Kehoe. As a young
infantryman in Vietnam, I saw that look many times before. My daughter is a
Volunteer Firefighter with West Valley Station #2. I would like to obtain a
copy of your photo of Firefighter Mike Kehoe if that is possible?? You cap-
tured a
unique moment that few people get to experience in life. When anyone wants
to know what unselfish, duty and sacrifice looks like in the face of death,
they need only look into the face of Mike Kehoe. You have my sincere condo-
lences for your hurt and your loss. We will never forget. God Bless America.

Most Respectfully yours,

Robert Himrod & Family
Yakima, Wa.

From: Hyland, Mary L.
Sent: Wednesday, October 03, 2001 12:16 PM
To: 'John Labriola'
Subject:

Dear John,
I just read the account of your escape from WTC 1. Three weeks later I
am still devastated by events and it is encouraging to read of someone's
escape in light of all those lost. Thanks for writing. My husband
works in Manhattan (I call him Mr. New York because he loves the city
so) and is approx ten minutes from what is now being called Ground Zero.
He is a civil engineer employed by the railroad and saw many horrific
things the first two days. We live in Philadelphia and for several
hours he could not be reached. John was fortunate enough to make it
home close to midnight, at which point we sat and watched the mayor and
he cried. I have never seen him so devastated. I believe I aged ten
years that day. Even our eight year old daughter has not been immune to
the events of September 11. The Saturday that followed she had a piano
lesson and cried during practice. We assure her as often as we can. It
breaks my heart.

Our sympathies and love go out to all those whose lives have been lost,
shattered and forever changed. Your words to use one's head rather than

130

finally restored power on our street. What you are going through reminds me of
these things, which I had forgotten, but it is still so minor compared to
what you have gone through.
I want you to know that you will see things get back to 'normal', but some
things will always be a reminder of what happened. You will see the power of
mankind helping others, people being nice to each other and smiling. I find
it comforting that you were able to take refuge in a church until it
was safe to go back outside. My church was destroyed during Hugo and it
took over a year to get it restored. But the people still met and we became
a stronger congregation. Please know that others are praying for you and
everyone else who was touched by the tragedy. We just have to trust in God
and in our government that they will bring those responsible to justice so we
the world can live in peace.
Thanks,
Linda Jarriel

From: Nancy Norton
Sent: Saturday, September 29, 2001 3:15 AM
To: John Labriola
Subject: Your Story

Just wanted to say that I'm thankful that people made it out of the
towers. I can't imagine what you went through. My heart goes out to you
and all the people of New York.
My thoughts are with you.
Nancy in Riverside, California

From: ruta kleiman
Sent: Saturday, September 29, 2001 5:17 AM
To: John Labriola
Subject: Response

Your story is amazing, including the ending! We in Israel live with the terror
for long time and sometimes children / men / women don't come back home
because a Muslim Palestinian blows himself inside crowded markets, restaurants
or even discotheques full of young people! Our big army is helpless because
they can't just shoot somewhere cause those Muslim groups are inside a civil-
ian places (and that is the reason you can see on CNN big tanks facing
Palestinian children) - it is a very good picture for the news but all it
really shows is the helpless situation we are in !!! I really hope America
would be able to fight back because it is so much stronger than Israel -
because it has not only military power, but also diplomatic power !! I truly
wish you a lot of happiness in your life and wish America success in it's war
Ruta Kleiman,
Israel.

lose it were well put, considering the anger that rises following the sadness and helplessness of such a horrific event. I'm glad you got to go home to your wife and family. I can only imagine what she must have felt in those first minutes, knowing where you were.

I had a conversion with an outside technician this morning who wondered what the mindset of America will be in six months' time, being the laid back kind of folk that we tend to be. Will we forget..put the flags away? I told him I didn't think we'd become lax. Too many lives have been lost and there is always the threat of more to come (God forbid).

I hope you have a happy and peaceful life and can share your positive attitude with others who may have lost theirs.

God Bless!

Mary Hyland
Philadelphia, PA

From: Island Princess
Sent: Thursday, October 04, 2001 1:32 PM
To: John Labriola
Subject: a thank you

Dear Mr. Labriola,

I know you do not know me but I am writing you today to say "thank you" for gathering up the strength and the courage to put up on the internet your experience of that tragic day of 9/11/2001.

Why I am thanking you is that to us, people who may be thousands of miles away from the devastation and once removed from it I think do not fully grasp all the feelings, emotions, horror and sometimes quilt that the victims who survived are dealing with.

I sat like millions of others on the Tuesday morning and watched in horror with my mouth gaping open in disbelief at what I was seeing. I stayed glued to my television set for what seemed like a lifetime waiting and wanting to hear that miraculously more people were found alive and searching for an explanation as to how such evil could become to so many innocents. It wasn't until I got online that evening very late that the full impact as to what just happened to the whole world and to the Brotherhood of Man hit me. I saw the faces of the injured and the dead, the missing and the found the families and the friends. They were right here in front of me. Very up close and personal. I sat and I cried for everyone affected and for the world. These pic-

tures I was seeing on my monitor were as if I was looking into their souls and hearts and lives. I saw black, white, young, and old. I saw thousands of innocent lives taken away from their loved ones in an act of violence that not only hit those involved but it affected all of us. I saw a crime committed against humanity and all peace loving peoples of the world.I then the next day started reading the stories of many of the victims and survivors...The Chaplin who gave his life while administering last rights to a fellow firefighter. The heroes who rushed up into the towers as others scrambled down. The gentleman who would not leave his friend who was a quadriplegic. The CEO who lost everyone of his employees. The firefighters who's lives were spared because they would not leave a lady who had to stop and rest. They were willing to die doing their job of protecting her and in return they survived because she picked the right moment to rest. The story of the new little daughter born of a man still missing and how her mother wanted to wait for her husband to be found to name the baby...the doctor then named the new life "Hope".

I read of the heroes who knew if they did not take back over the controls of the doomed plane they were on many more thousands may be lost. Many of our military were lost at the Pentagon. Some were leaders who's lives were lived everyday protecting the freedom of our country. And I saw our flag. Old Glory, who through all of the destruction and despair was still standing. She was a little worn and torn but she was there and beautiful and when the awesome picture of those brave firefighters who helped her to stand straight again was taken I believe this was a sign. A sign to everyone of the world. A sign that is telling us..."You may knock us down, but you can never knock us out".

Thank you Mr. Labriola for sharing with the world your story and words. We must never forgot this tragedy that has befallen us. We must remember those who died and those who lived through it. If we ever slip back into our old ways and old thoughts then all is for not. These innocents will have died in vain and we will again be left exposed for all and anyone to do the same if not worse to us again.

One other thing I would like to mention sir. Out of all the accounts and stories I have read and seen on television over the past couple of weeks. Yours was the first to mention about the blood. How it was everywhere. Innocent blood that was shed which ran all together. The blood of many that represented the blood of the human race. I am not going to try to even say I know how to go about punishment for whomever did these horrific deeds. All I know is that we all must pray to our God. Whomever our God is, be it Christ, Buddha, Allah, etc. Pray to that one higher being for guidance and light. Thank you very much for reading my letter.

With much respect,

Island Princess

From: Terry Halsey
Sent: Monday, October 08, 2001 9:58 AM
To: John Labriola
Subject: Shared Experience - WTC

Greetings,
The photos are incredible. I've had to stop looking at these things
as my mind and heart cannot contain the horror....I've just completed
a website that is gathering the first-hand accounts of survivors and
witnesses of the WTC attack.
I want to collect details about people helping one another, and
courage, and love of family and friends. I hope that this collection
of first-hand accounts will be a courageous monument, testifying to
the best parts of us that arise in times of crisis.

Hope you'll visit and leave a few words...
best of luck in all your endeavors,

Terry Halsey
New York, NY!

From: Leanne Bradburn
Sent: Sunday, October 14, 2001 10:36 AM
To: John Labriola
Subject: Your Account of 11/9/2001

Dear Mr Labriola,

You do not know me but my name is Leanne and I have just read your
account of events on the internet. I find that words fail me when
referring to this tragedy and my hopes and prayers go out to you, your
family and friends. "All the great things are simple & many can be expressed
in a single word: Freedom, Justice, Duty, Honour, Mercy, Hope..." - Winston
Churchill I would just like to say that although I am not affected personally
by the unspeakable events of 11/9/2001 my heart goes out to all those
effected, involved in the retaliation and those who will soon be
involved...Australia is with u !!!!

From: Angelina Drews
Sent: Saturday, November 17, 2001 11:07 PM
To: John Labriola
Subject: Response to September 11th article

Thank you for taking the time to share your experiences of that terrible day.
I'm a New Yorker by birth currently living in another state. I've wanted so

much to help in some way. I've given money, I've prayed and I've cried for all those who were lost and their loved ones who must now live without them. Somehow none of that has felt like enough. Indeed what could ever be enough for what happened that day. It's torn through me. I, like everyone who watched on t.v. stood in horror at the images before me. I wanted to run and get on a plane and "go home" to help my people. I'm a nurse and I wanted desperately to put a giant bandaid on "my city". The ache doesn't go away. It became harder and harder to watch the news. I have only just gotten to a place where I'm looking at stuff on the internet. I guess that is why I'm writing to you. The need to reach out in some way to those who were there. You are so blessed to have survived. I'm glad you made it out. Glad for you and all who love you.

Sincerely,

Angelina Drews

From: Nathalie Gobeil
Sent: Sunday, November 25, 2001 9:17 AM
To: John Labriola
Subject: september 11

Hi
My name is Nathalie Gobeil, I'm from Canada, Québec.(My english is not very good.. sorry). Just want to tell you that i have read your article on framer-ate.net, and i feel your sadness and your pain... I wanted you to know that i do feel your pain. What happens was terrible. Americans are our cousins. We are with you, praying for a best world and for all your losts.
God bless America!

Nathalie

From: Dan Dakin
Sent: Thursday, February 07, 2002 2:31 AM
To: John Labriola
Subject: God Bless

I'm sure you get a lot of emails from your website but I just wanted to say God Bless and thanks for sharing your story. I'm from Niagara Falls, Canada and was as shocked as anyone to see that devastation.

Frankly I'm speechless right now after reading your story.
So I'll just say God Bless.

Dan Dakin

GOOD MORNING AMERICA

My 15 minutes of fame started on 9/13 when I got a call from Brad Herbert at ABC asking if I'd be interviwed on Good Morning America. Brad arranged for a limo to pick me up at 8am the next morning.

The driver introduced himself as Howard Pew. It turns out Howard worked as a firefighter by night and drove a limo for GMA as his day job. Howard was pretty tired from working the pile the night before. He'd had just enough time to go home and shower before heading back into Manhattan to pick us up. He asked me why I was heading down to GMA. I told him about the images in the stairwell. "That was You!?" he reached over to the passenger side seat and grabbed his copy of *The Daily News,* opened it to page 5 and handed it to Jen and I. There, staring back at us, was a full-page crop of an image I had taken in the stairwell of a fireman ascending the stairs. It took my breath away, not because I had taken the image, but ratherthe caption, which read:

Firefighter Mike Keogh makes his way up the stairs of mortally stricken One World Trade Center to help evacuees as a stream of people goes down in a photo taken by John Labriola who had an office on the 71st floor. And Keogh made it to safety

I was elated; until then I was sure that every one of those brave men I had photographed had died. Howard made a gift of the newspaper. It is one of my most valued possessions. When he delivered us to 45th street I was still bouncing off the walls. I must have looked a little too happy as a disaster survivor. I couldn't help myself. While I was in makeup, being briefed by a production assistant about what to expect, I told them what had just happened. They immediately began planning to get this into the program, starting by verifying that Mike really had survived. Here's the transcript of the interview courtesy of ABC GMA.:

CHARLES GIBSON, ABC NEWS: Well, so many amazing stories. We have one more amazing story to bring you. I want to introduce you to John Labriola. Have I pronounced your name correctly, John?
JOHN LABRIOLA: You did.
CG: All right. Worked here--worked here in New York. Worked at the World Trade Center towers in-- what floor?

JL: Seventy-first floor, tower one.
CG: Tower one. Plane hits on Tuesday.
JL: I was in a conference room with six others. And immediately, it seemed like a plane had hit. I remember discussing it and the building rocked about six feet in each direction. And it was kind of silly to try and stand at that moment.
DIANE SAWYER, ABC NEWS: And what is so extraordinary is you and your colleagues head for the stairwell and start on the way down. You are able to take pictures. First of all, how did you have a camera?
JL: Well, I took pictures all the way into work that day, including a picture at 8:05 of the Greek Orthodox church in the--in the--in the tower.
DS: Now what are we seeing? This is on the way down.
JL: This is on the way down. Actually at different points in the stairwell, we had--we had to stop. And around the 35th floor, firemen started coming up the stairs. And these are some photos of folks here as they went up.
CG: Yeah, you're coming down in your regular work suit, and they're coming up, not only with full fire equipment but carrying massive amounts of gear.
JL: It was amazing. This is an image from the first moment I stepped outside. I looked up, and I couldn't believe what I saw. And no one could believe it.
CG: Both towers, at that point, consumed. There's a picture of the church. That's actually in the aftermath with the dust all over the church, right?
DS: Trinity Church, right.
JL: I was able to get into Trinity Church and take some pictures between the time when the first tower had fallen and the second tower fell. We were trying to decide whether we could get out of the church or should stay in the church at that time.
JL: Yeah. That really does look like a bomb has hit when you see...
JL: That's Wall Street.
CG:when you see the ghostly eeriness of the clouds over Wall Street, right?
JL: This was on my way home. I just looked at that photo, and it's ironically beautiful. But I was pretty safe at this point and happy, but awfully sad.
CG: Those pictures on the stairwell that we saw, just a

couple of them. It was very orderly on the stairs going down.

JL: People showed amazing composure. Any time emotions bubbled up, there was someone to calm.

DS: And were the firefighters telling you what to do? Were they giving instructions?

JL: The firefighters didn't say a word as they went up. But as we got down lower, there was a line of--of rescue--emergency workers who were encouraging everyone to move along.

CG: Were there any--I'm curious about this--how orderly it was going down. Any screams from people?

JL: No, not--not that I heard. Just--just deliberate-- you know, there were times we had to stop and people were frightened because they didn't know why.

CG: Right. Like a traffic jam, I suspect, coming down.

JL: Yeah. There was nowhere to go.

CG: And as the firefighters came up, everybody immediately cleared out and gave them room.

JL: Of course. Yes. There were some times where people were brought down from above us who were in much worse shape than we were.

CG: Now tell us--tell us about this picture. We saw this picture that you're seeing on the screen, and it's also in the *New York Daily News*. Very prominent. Tell us about this picture, that fireman.

JL: On the way in--first of all, I didn't know if any of the men who went up survived until this morning. On the way into your show, Howard Pew, your limo driver, who's also a fireman, shared his stories, because he has been working down there in the evenings. And he asked why I was coming in, and I told him I was in the tower. And he said, 'Oh, did you take photos?' And I said, 'Yeah.' And he said, 'Well, look at this.' And he showed me--this is the actual paper he gave me.

DS: We should point out, you're a--you're a computer consultant. You're not a photographer.

JL: No, I'm not a photographer.

CG: But this is your picture.

JL: That's my picture, and I didn't know that--according to the *Daily News* anyway--I hope it's true with all my soul and heart, I hope it's true--that Mike Keogh is alive.

CG: This one.

JL: That fireman. I didn't know until this morning

just before on air, that he--he's alive. And I'm--I'm so happy for him.

DS: When you got down, you called your wife. What did you say to her?

JL: Actually, I called her--I called her from the church in between the--the first--first tower falling and the second. And I promised to--to make it home to her.

CG: I--I want to read the cutline on this picture that's--that's in the paper. I'll show the--the paper again. This is the picture you took. And--and--and I know it's not only great news for his family, but it's also great for you. 'Firefighter Mike Keogh makes his way up the stairs of mortally stricken One World Trade Center to help evacuees as a stream of people goes down in a photo taken by John Labriola who had--who had an office on the 71st floor. And Keoghmade it to safety.'

JL: I'm hanging my hopes on that line right there.

CG: You know--you know--you've never seen this fellow before.

JL: Never.

CG: No, but you take a picture like that. And what a great face! You see him going up. I mean, there's a--there's a lot of realization of reality in that face as he heads up the stairs.

DS: If we could, I'd like to go back one more time to the scene of the single individual standing in Wall Street, the haunted cathedral scene of Wall Street, and have you describe to us once again what it is. There it is. So this is just a man with a briefcase. How long-- how long had it been since the blast now?

JL: Well, this is about 45 minutes, 50 minutes after we left--left Trinity Church. And groups of us had gotten together. We had towels and--and...

DS: As you say, it's--it's an iconic scene.

JL: It is an iconic scene.

DS: We won't forget it. John Labriola.

I left GMA studios high as a kite on the rush of adrenalin that was still coursing through my veins. I could not imagine going back inside so I decided to walk home to 90th street. I must have looked ridiculous smiling ear to ear, striding through the city. I didn't think I would ever smile again after 9/11. Now I was smiling so much my face ached. I thought if Mike had made it out, maybe the others made it out too. This gave me hope. And hope is a powerful thing.

Manhattan from Brooklyn: the skyline after September 11th.

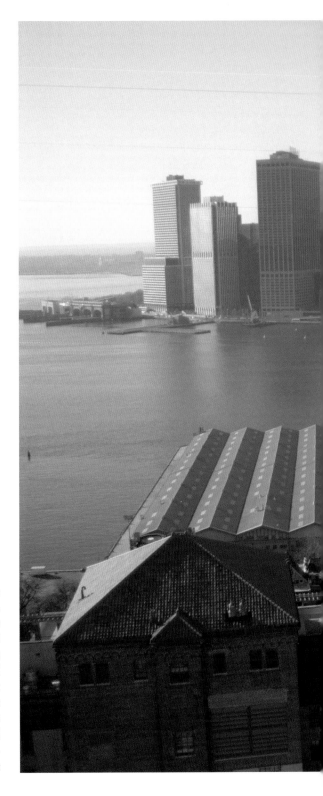

Going To Ground Zero

I called the police and fire departments to tell them about the photographs I had taken inside the tower, thinking that they might possibly be of help in some way with the rescue or even with forensics. I directed them to the web site and the images. The site kept crashing as it struggled to keep up with demand, so I burned CDs of the images and the text of my account and decided to hand deliver them to the Police Command at Ground Zero and the Fire Command in Brooklyn. I took a taxi to Union Square and walked downtown from 14th street, passing through check-points by explaining my mission or showing my Port

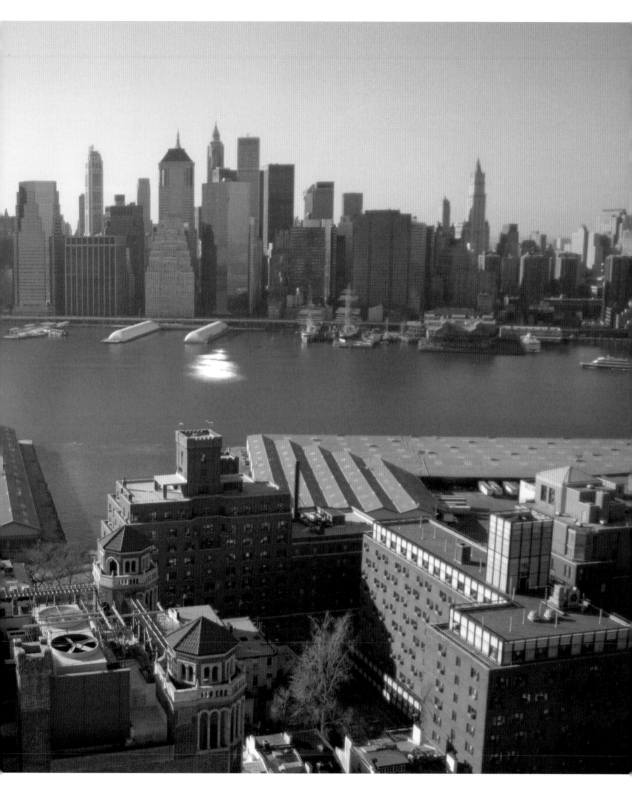

POLICE

OKLAHOMA CITY

SEAL OF THE CITY OF OKLAHOMA CITY

GER SACHSEN

DRESDEN

02-21-02

Sergeant T.V. Southern

In Loving Memory

of

PHILIP W. MASTRANDREA Jr.
September 11, 2001

"Live today like this is your last, for this is not a dress rehearsal."

Philip W. Mastrandrea, Jr.

Authority World Trade Center ID. One officer joked that my ID wasn't valid anymore. It took me a moment to muster an awkward laugh. I passed homeless Manhattanites with their belongings on the street, and memorials and posters of the missing taped to mailboxes, lamp-posts, walls, windows, and doors. As I traveled further downtown, the smell and taste of destruction that hung on everything grew stronger. It stung my eyes, transporting me back to that day and to the sound and feeling of the building's collapse. I closed my eyes in an attempt to blot the memory from my mind but I could still taste it. When I drew nearer to St Paul's, I approached an officer, who after listening to my story, took me by the arm and escorted me down into what felt like the bowels of hell. I don't recall his name, but I will never forget his warmth and compassion.

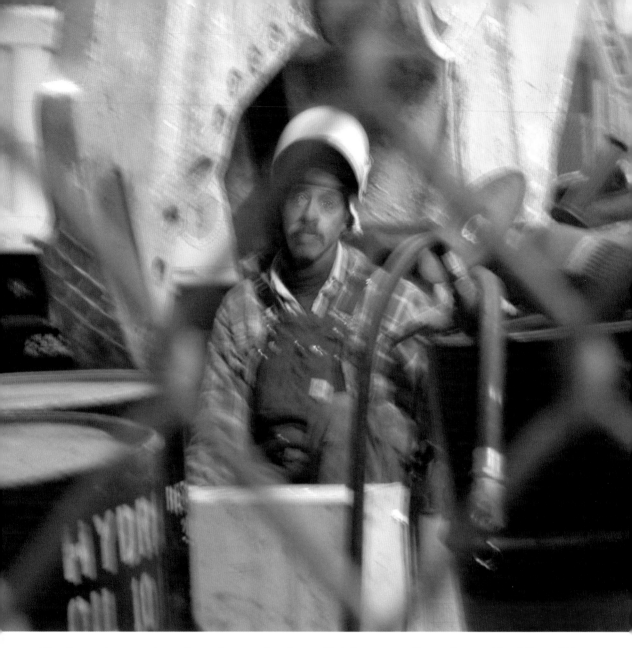

The devastation was almost beyond comprehension. Just walking across Ground Zero was difficult, not only because of the uneven terrain but from the disconnect of my feet and eyes to my brain as I tried to take in the once familiar, now unrecognizable surroundings. I gazed upon scarred buildings, across the pile of twisted steel and concrete, none of which should have been visible from where I was now standing. The officer was patient, understanding my need to adjust my pace in order to go forward into this hell.

He led me to a trailer on the east side of Ground Zero. I was met there by a commanding officer with the look of a grandfather. His eyes were filled with sorrow. I handed him two copies of the disc. Explaining that I hoped they might help to show where people might be trapped. He looked at the disks as though they were alien objects but thanked me nonetheless, and patted me on the shoulder like one of his grandchildren. He looked at me again with those soulful eyes, then went back to attend to his men. It was clear that he knew, as

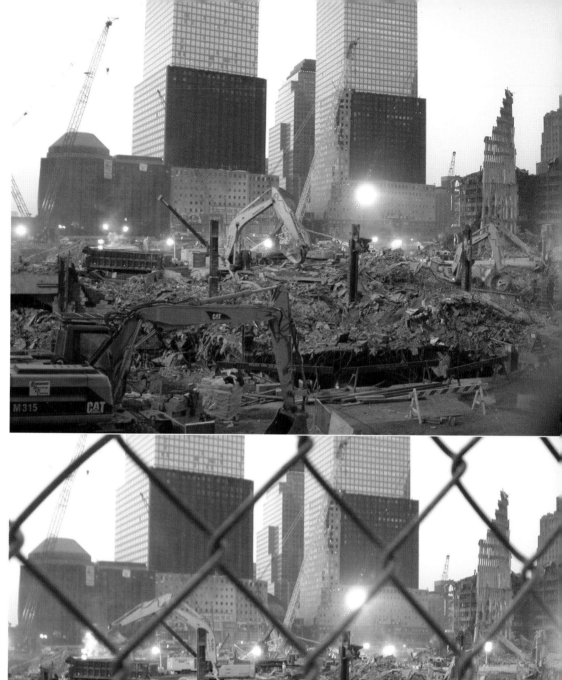
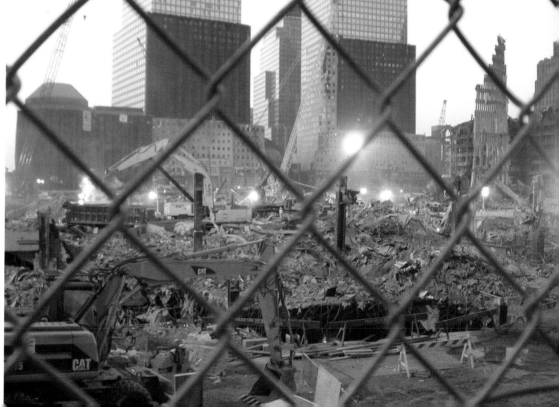

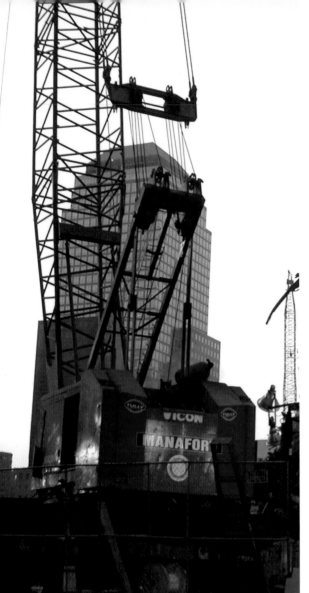

I now understood, that no person, or thing, could have retained its original shape—could possibly have survived—such complete destruction. I walked out of that terrible place alone, thoroughly shaken and in tears. Somehow I found my way across the Brooklyn Bridge to the Fire Command in downtown Brooklyn.

When I arrived I explained to the fireman at the desk who I was and why I had come. My words rang hollow now, with the knowledge I had garnered from witnessing the pile. I handed him the two copies of the disc containing my images, thanked him and left to find my way back home.

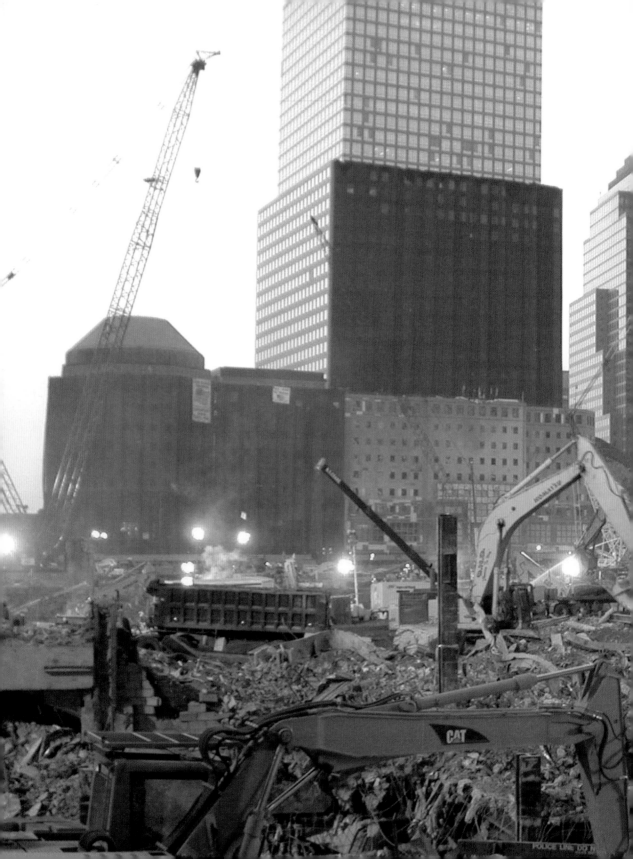

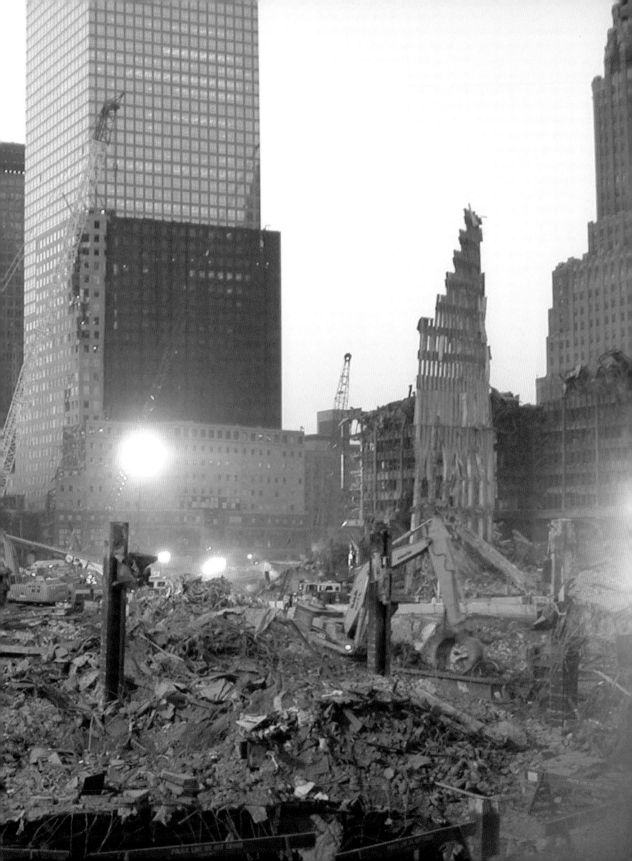

Mike Keogh

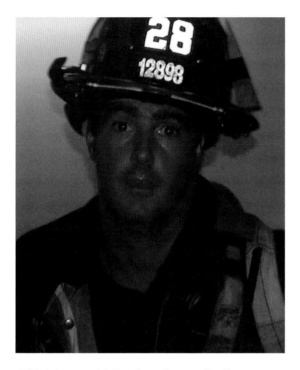

I think it was mid-October when we finally got up the courage to drop in on Mike Keogh's firehouse. Jenny and I had dinner downtown at Sun Lok Kee; a favorite Chinese seafood restaurant on Mott street, below Canal, in China Town. We walked up to Little Italy for dessert. It was a spur-of-the-moment thing. We decided to pick up a box of pastries from Ferrarra's and hand deliver it to Mike's Engine Company in the East Village. Jenny and I were a little apprehensive to touch the scars again, and I felt pretty guilty about turning Mike into the 9/11 poster-boy; from what I had read in the press, he was not thrilled with the role either. When we arrived at the firehouse there was a civilian woman ahead of us with a basket of fruit for the men. We waited our turn by looking at the memorial that was set up honoring the six men who were lost on 9/11.

When it was our turn, we went up to the lone fireman, I handed him our gift of pastries while explaining that I was the guy that had taken the picture of Mike. He said "Dat was you! — Your killin' us! — Dat guys head don't fit in his helmet!" with

that he handed me back the pastries, took Jenny by the hand and led us back to the firehouse kitchen, all the while exclaiming for anyone within earshot, "Your not gonna believe who I got here". He sat us down at the big communal dining table and immediately invited us to share dinner. Tonight it was Chicken Franchisee and Fettuccini Alfredo. We politely declined, explaining that we had just eaten dinner in China Town.

One of the men came by with soft drinks while another got word to Mike who was upstairs. From where I was sitting I could see into the kitchen where a group of firemen where preparing the chicken and pasta. A huge fireman came by to make our acquaintance by bear hugging me while shaking Jens hand.

Mike came down. He looked older without his helmet. We shook hands then hugged one another. He settled in across the table from us, and we began talking all at once. He had a crumbled up napkin in his hand with the same reporters names and phone numbers scribbled on it that had been in contact with me. If I was inundated with requests for interviews, he was totally swamped by them. I apologized for taking his picture and bringing all this on him. He said there was no need. That it wasn't my fault. But I could sense he was getting tired of it. He told me that reporters had even called his wife at home erroneously asking how she felt now that her husband had died...

We talked for a half an hour or more, swapping stories. I retold the story about how I found out he was alive. I couldn't thank them enough. The whole firehouse was milling around the table as we talked, quietly hanging on every word. They were so completely genuine.

By now dinner was ready. They offered to set a plate for us for the fifth time. We left them to their meal. There was no way to fill the void left by their six fallen brothers, memorials to their loss hung on everything. And yet, even in their sorrow they were heroic and gracious. For me that any of these guys made it out was a miracle. If I get down, which I sometimes do, all I have to do is think about the day I found out Mike was alive, and I am transformed.

Survivor Guilt

Sometimes, when I get a little down I feel a certain amount of guilt because I know that whatever difficulty I might have going forward, pales in comparison to what the victims' families from that day are still going through. Still I've noticed a common sadness among survivors. As a group the majority of survivors are anonymous in comparison to the rescue workers, emergency workers, and the families of those who were lost. I think many survivors, unavoidably, were left out of the social interaction that may have helped them heal. It is easy to forget or discount that the survivors suffered a great loss that day. They are grateful and fortunate, but I wonder how in the aftermath, and in the face of so much pain and sorrow, survivors and their families are faring. As a group they are not easily organized or administered to. In the end I hope time will work its magic so that we will someday find each other and a little peace. For now I think many of us have postponed processing the event. 9/11 in itself is so indigestible that many have chosen to push it aside, if only to make room for, and be confounded by, the world events that have followed in its wake.

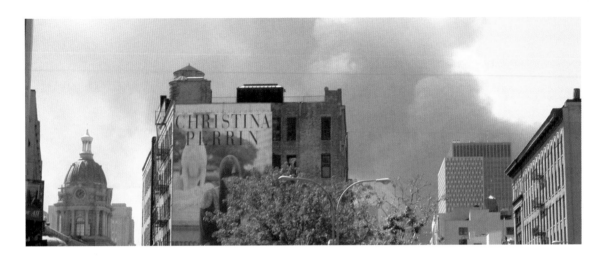

The Smithsonian

David Friend, Editor of Creative Development at *Vanity Fair*, had worked some of his magic, by calling the Smithsonian to encourage them to meet with me and see all of the images I had photographed that day; but, according to the Smithsonian Institute's Michelle Delaney, they had already intended to contact me . David gave Michelle my number, and arranged for us to meet in his office at *Vanity Fair* the next time she had reason to be in New York.

David was still trying to figure out how to include my images in his one-year anniversary article. Michelle was very direct over the phone; even before I showed her all of the images she made it pretty clear that she and The Smithsonian wanted to collect my images and possibly my camera for the National Archive. My head was growing bigger by the minute. She told me about an exhibit of The Smithsonian's September 11th collections that was to coincide with the one-year anniversary. Though space was limited, there was a small chance that some of my images might be included.

So far I was in good company; the photographers whose work was being considered included Bill Biggart, the only photographer who had died in the attack on the Trade Center, and James Natchway, who's extraordinary body of work documenting humanity made him something of a hero of mine.

They found Bill Biggart's body on September 15. Biggart's body was pulled from the rubble, and identi-fied by his fingerprints. In the end they went with an extraordinary exhibit of Bill Biggart's photographs that they had found in his ruined cameras and also a selection of images and artifacts from the site of the plane crash in Pennsylvania, and a number of images from the attack on the Pentagon.

The exhibit, called *September 11: Bearing Witness to History*, opened on the one-year anniversary of the attacks and ran for four months. At the exhibit visitors were asked to contribute their own stories to a digital archive by answering two questions: 'How did you witness history on September 11?' and 'Has your life changed?' I guess this book is my attempt to answer both those questions.

Both Natchway's and my work didn't make it into the exhibit. I didn't feel all that bad given I had a hero of mine for company. David had told Michelle of my interest in doing a book based on the images I had captured. Michelle was enthusiastic and promised to put me in touch with her colleague Ellen Nanney at the Smithsonian.

In the weeks that followed I spoke with Ellen by phone several times. It turned out that The Smithsonian Press was not interested in publishing my book; but Ellen asked if I would be interested in working with a publisher whom she had worked with many times in the past who had expressed an interest. That's how I came to meet Sean Moore of Hydra Publishing, the publisher of this book.

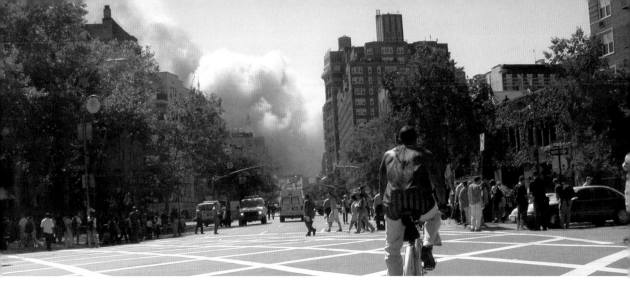

Time Life

Bobby Baker Burrows is the Editor for Time Life Books and the daughter-in law of Larry Burrows the famed photojournalist for *Life* Magazine, who was best known for his work in Indochina. In February of 1971 Larry was killed along with three other photographers when his helicopter was shot down over Laos. Like most people of my generation I grew up fascinated by the images and stories in *Life* and *National Geographic,* as boy I remember reading about his death as well as the death of Robert Capa and being blown away by the amazing images they had captured. So much of the history I remember from my childhood is punctuated and illustrated by what I had seen in *Life*. It was a great honor to have my images and story published in a Time Life Book. It was pretty exciting for me entering Time Life's offices and to be interviewed. In my mind I was on hallowed ground.

The day before the interview I had been to Time Life's offices on 45th street and met Bobby Baker Burrows for the first time. I had dropped off a disc containing my images and the account. At lunchtime on the day of the interview, I was at work in a temporary trailer at Newark Airport on the cellphone with my sister AJ in Florida. We were both online looking at a page on *Life's* web site (a section dedicated to Larry Burrows, showing all the images he had done for *Life*). We were looking at one of his more famous pictures from 1966 of a wounded marine reaching out to a comrade stricken during fighting for Hills 400 and

484 near Dong Ha, South Vietnam. Just then, my colleague, Larry Gardenhire, walked into the room, opened his briefcase, and produced a hard copy of the very image we were looking at online. I was shocked. Larry pointed to the wounded black marine in the photograph and said excitedly, "That's my uncle!" As it turned out, Larry Gardenhire was helping his uncle Jeremiah Purdie (the injured marine) to write a memoir about his military life. Larry was even more astonished when I told him that I had met Larry Burrow's daughter, Bobby, only the day before. We both sat there looking back and forth between the image on the screen and the image on the paper in front of us.

I told Bobby about Larry Gardenhire and his uncle Jeremiah. She was amazed; her husband Russell Burrows had met with, interviewed and written about Jeremiah and this particular image in the past....

The book *Under One Nation* by Time Life Books was done beautifully and I am grateful to Bobby and her staff for that. But for me the thing I value most about this book is the number of people that have contacted me after seeing themselves or a loved one in one of the 12 images published in there. I have a need to know what happened to the people in my photographs. I realize that I captured only a few of the thousands lost that day, but these few are the ones I feel somehow responsible for. I am incredibly happy each time I find out another person I had taken an image of made it out of there alive.

Chuck Zoeller

Chuck Zoeller of the Associated Press has had an invisible hand in my life since September 11. He has taken it upon himself to gently and effectively encouraged and shepherd me forward through the maze of possibilities and opportunities (some of which he cultivated) that have arisen from the images I captured on 9/11. When I first spoke with Chuck I was immediately taken by the sense that he acted somehow in a way that was devoid of ego.

This was pretty amazing in a world where strong personality seems ro be a key ingredient to success. Chuck managed to relate to people as people while maintaining his focus on the power of the image to tell a story. He loved his job, and therein lay his enormous strength. We first spoke soon after I was notified that the Associated Press was going to nominate me for a number of competitions including the Pulitzer Prize for breaking-news photography. Chuck was tasked with putting the package together for the Associated Press that would be submitted to the Pulitzer jury for review.

Aside from his obvious enthusiasm for his work and his involvement with the Pulitzer Prize Nomination and award process, he always seemed to downplay his own role in all this and his accomplishments. I found out later that Chuck was actually on the jury of the Pulitzer committee that year. So he would have to abstain from voting (but not from lobbying) for me. It was pretty exciting, I gave Chuck a copy of the account I had written. He asked me which images I felt were the strongest and why. In the end AP created a bound album of my work, which included the 12 images AP represented along with an introduction and my account. I was feeling like the Forrest Gump of Photojournalism; no matter how wet behind the ears I was, everything just seemed to work out for the best. Imagine what a ridiculous position I found myself in when I learned that I did not win the Pulitzer; for a good day I was disappointed and envious of the entire staff of *The New York Times* for winning in my category.

In the end I think that Chuck was more disappointed for me than I was. It didn't take me long to feel good about the experience; I mean how many neophytes ever even get to be nominated for a Pulitzer? Then an inescapable thought came creeping in, the thing that made my images unique and of interest was that they were the only ones to survive from inside during the attack. How could I waste my time concerned with my own happiness and recognition when there was at least one other photographer who didn't get out of there named Bill Biggart. And the odds are that there were others as well. I promised myself never again to waste time feeling sorry for my own good fortune. I decided to take a page out of Chuck's book; to focus on working hard at the things I love, and try to leave my ego at the door.

The Associated Press is a great and storied organization; for a novice like me, I thought, how cool would be to be represented by them! The Associated Press is 'Non Profit' in the sense that they distribute images to their members (who pay a annual fee for the privilege). If I wanted to get the images to the most people then The Associated Press was the best possible place for them. Of course I had no understanding of the business of photojournalism, mostly I didn't understand that the majority of photojournalists make little or no money; big dollar photo sales are rarities, and tend to have a limited shelf life.

A few of my images were deemed iconic, but I wasn't smart enough or greedy enough to parlay them into much money. The Associated Press represented 12 of the 110 images I captured that day. Gamma Press represented 28 images, and I represented the rest; this was a pretty confusing and unorthodox approach developed not by design, but because I really had no idea what I was doing. While the 12 images Associated Press represented satisfied the world's newspapers and television news programs, Gamma Press leveraged their great relationships with prestigious international magazines like *Paris Match* and the German magazine, *Geo* who otherwise might be reluctant to use an image that was already widely available and published. For direct sales people found me by word of mouth, or through the account and images I had posted online, or through seeing the images Gamma Press and the Associated Press placed for me in newspapers. Now that I've been around the block a few times, I find it impossible to imagine how any photojournalist could make it today on his or her own.

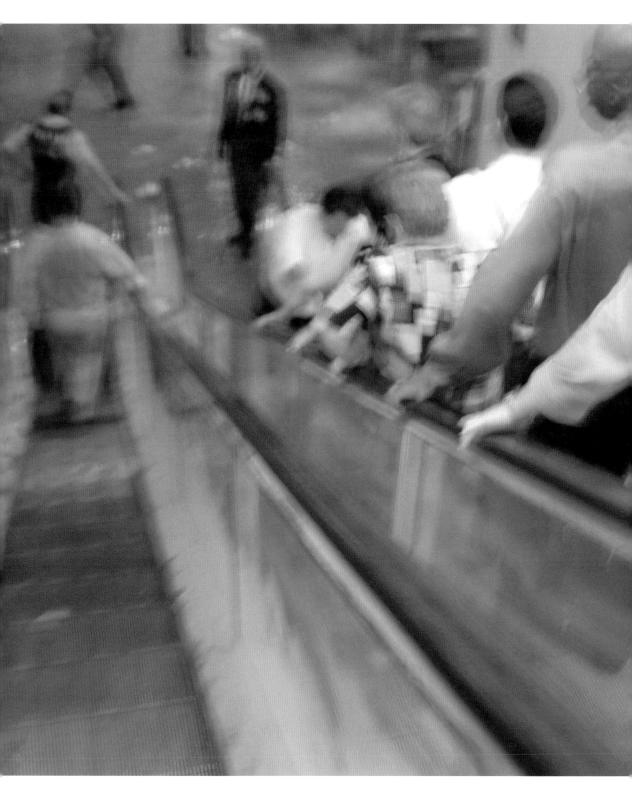

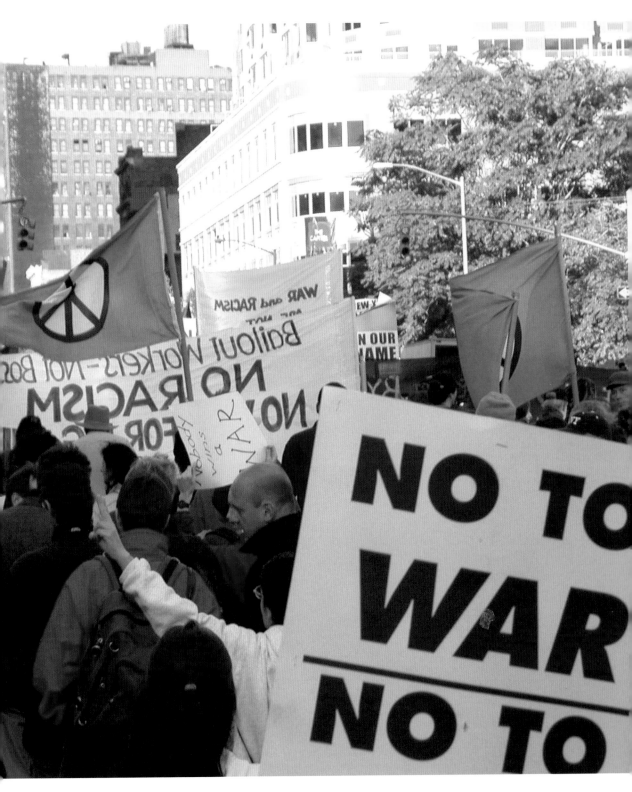

The Anti-War Movement

While we were still stunned by the terrible events of September 11, our leaders formulated policies and began acting on them. Our case against Afghanistan was made and our response was quick—few argued that the Taliban regime was not linked to the attacks on America. Clearly, with regards to the Bush administration's case for war, lines had been drawn, and a drama was unfolding that required easily identifiable villains and heroes.

However, I believe that the single most unhelpful statement a president could make given the circumstances was: "either you're with us or against us". This statement gave the pro-war movement justification to attack any debate over U.S. policy in world events as un-American. I knew at that moment that the Anti-War effort was lost.

I assigned myself the task of photographing an anti-war march that was to be held in the lower-west side of Manhattan, protesting the impending war in Afghanistan. At one point during the march I found myself caught between the protesters and an angry mob. The mob was shouting insults, threats, and racist remarks at a small group of protesters who were chanting peace slogans and carrying signs that read "No to War, No to Racism" and "New York Not In Our Name".

To the mob, in their frustrated anger, all Afghanis had already become terrorists and the anti-war protesters were seen as aiding them. I wanted to scream at the angry mob "I was there in the building. If anyone deserves to be pissed off it's me. Do not seek your revenge in my name." but of course I didn't, and remained quiet.

That there appears to have been little or no debate within our government preceding the onset of military action could be characterized as either reckless or decisive. Which wins out depends on the evidence produced after the act of war has been initiated. Because the US acted so swiftly, instead of debates preceding action we now have moments in history that will be scrutinized and debated forever. As painful as it might be to now have to defend our actions. The US now has to encourage the debate. And produce proof that we acted in good faith. On 9/11 I saw too many people die to be impartial or not

be careful. Those innocent men and women who died at the hands of the terrorists were of every color, race, and nationality. They deserve justice. We must not underemphasize that war, no matter how artfully carried out, can miss the guilty, and kill innocents. Believe me when I say that I want the guilty to be punished. If innocents are to shed their blood in our crossfire, then our targets had better be the ones who did this thing.

The case against the Taliban and the need to liberate Afghanistan seems clear enough. And I state emphatically that there can never be a plausible justification for what happened on September 11th. Still I would not be the only American to feel that our past relationship with the Taliban bears scrutiny, if only as a lesson of how terrorism is born and spreads.

I would hope that my willingness to look into every cause of terrorism, even those that were clearly not intended but played a part nonetheless, would not label me as unpatriotic or anti American. That this type of scrutiny has yielded fear of reprisal is clearly a throwback to the days of Senator McCarthy a character whom I have always considered shameful and almost comical.

I would not be the first American to feel that the case against Iraq was poorly made. Nor would I be the first to think that our government, in their zest to sway public opinion in favor of a military action in Iraq, traded loosely in half truths. War is serious business. It is not a bill to be passed through Congress or the House of Representatives to which you can add your out-of-context amendment, to satisfy your narrow constituency.

Our constitutional rights, especially our right to free speech and due process is what make America great. There is no time when it is OK to suspend our rights in the name of national security. In the end the people who find themselves on the receiving end of our military power had better be guilty.

It would be unforgivable if our military were used to take out an old enemy or to support some policy decision or strategy in lieu of delivering justice for the victims of 9/11 – in lieu of righteousness. I pray especially for those who give their lives serving our great country that this is not the case.

The Message from the Stairwell

Since September 11th I've talked to many people who were inside that day and many more people who watched and waited. I'm encouraged by how everyone treated one another in the stairwell and since. Each person I meet has a story to tell and an urgency to press the flesh; for a long time it was important to reassure myself that the person in front of me was real. It's incredibly important to feel useful in the aftermath. Just like so many of us in the days after the attack, I've been actively trying to account for as many people as possible. The images have forced me to continue this effort until this day. This book is part of that effort in that it allows me to reach a wider audience and show images that might not have otherwise been published. The book is also a vehicle for me personally to get the right message out about what I learned in the stairwell - something that is not always possible or apparent when my images are co-opted as a means to tell someone else's story.

In the stairwell, people treated one another so beautifully. No one stopped to think what color or religion the other human being was. We were all in this thing together. And this is how I pray people go forward from here. I'm not a Buddhist, or a Jew, or a Muslim, or even particularly religious but I do believe in God. Personally, I look at all religions as trying to explain the same phenomenon.

I have never understood why people choose to kill one another over whose explanation is better than whose. On September 11th a lot of people went through the unimaginable. For many the suffering is far from over. Please, if you read this, don't let my story or anyone else's become a reason to lose your head rather than use it.

The reality that catastrophic events would have catastrophic effects on my life was somehow lost on me. Of course everything had changed; there just wasn't enough time or reason to really digest what that meant. 9/11 is beyond reason and completely indigestible. Its dark cloud swallowed many of us whole; for those who survived, and for many who watched, the cloud will never completely settle. Maybe it shouldn't. As my friend Srg. Pete DeMonte said:

"We have been through something earth shattering and we survived. I hope that we all come to terms with what it all means to us…. We need to keep hope and faith alive, and need to work towards the future while (and I think this is the hardest part) never forgetting the past. As Harry Truman once said, "The only thing new in the world is the history that you don't know." I do not want anyone to ever forget"

As survivors our challenge is how to go forward. It's tempting to try making sense of something that is senseless. What we can do is try to digest what we can and move on.

On one level I was more lucid than I had ever been in my life. But just beneath the surface lay a place I couldn't yet go, maybe still have yet to go. Instinctively I understood that in order to survive, I had to distill from this event what was truly vital.

I clung to one idea like it was my life raft, it became my mantra: in the stairwell, people didn't lose their heads, they used them. We were mostly strangers, helping each other without concern for race, sex or religion. We conquered fear with love, patience, and tolerance. If it weren't for this fact, I would have died in the stairwell along with many, many more people.

For me this was an extraordinary confirmation of the basic goodness of people. Something I always hoped was true but could never state as fact. If I could only hang on to this simple truth and followed this example I'd be all right.

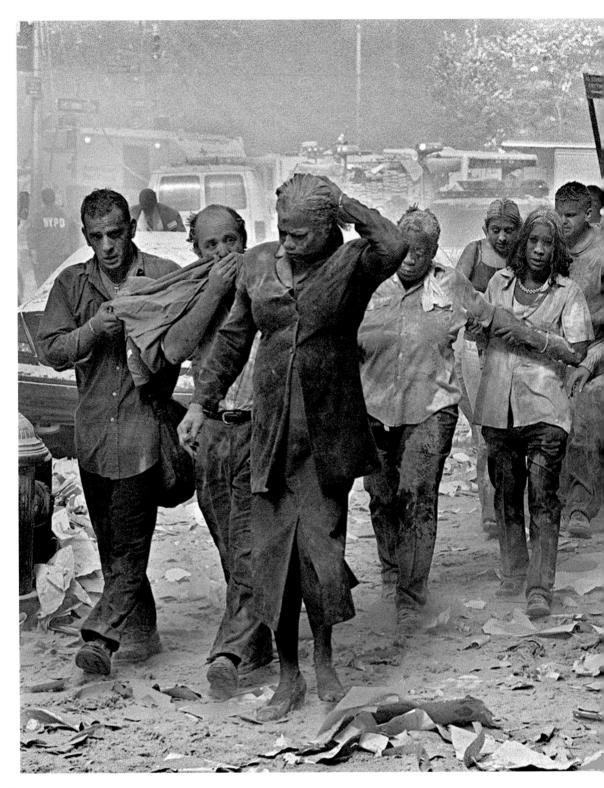

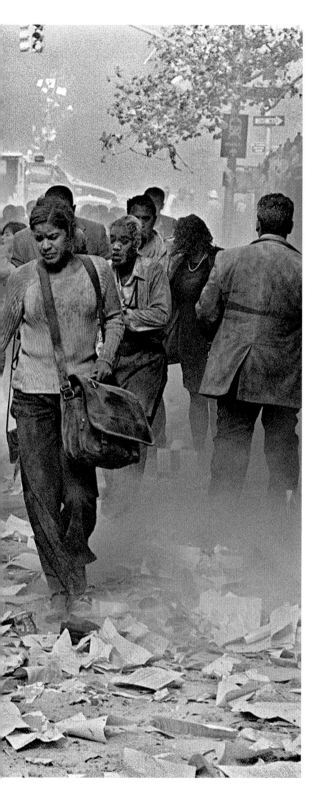

Gulnara Samoilova

Gulnara Samoilova is a photo editor for the Associated Press and a fine art photographer. I didn't know it at the time, but she worked for Chuck Zoeller. I had already seen her incredible images of ash-covered evacuees taken after the fall of Tower 2. Honestly I was much more excited by meeting her than by being in the documentary in which we were both to be featured.

She had captured her images by St Paul's Cemetery near to the spot I had rested with Safwat Wahba after exiting the building and mall. Here was someone who had been through hell and survived like me. We spoke before her interview and she showed me some beautiful prints that she had made. I excitedly showed her my images from the same area. We searched each other's images. There were some of the same rescue workers I had captured. There was the graveyard fence. There were the same emergency vehicles. Then there was the car she had hid under that protected her from the collapse of Tower Two and there were her unbelievably beautiful and poignant images of people covered in ash.

I was inside Trinity when this happened. I did share that awful event with her. This is a gap in time and experience that I did not have nor could have ever imagined, it was so incredible and horrible. We talked and shared our experiences through our photos until Hal pulled her away; it was time to do her interview. I found out later that it was not common practice for photographers to shoot black and white images for AP, and that now they do. Gulnara changed all that through her incredible images. I'm happy she did.

You can see more of her wonderful images and check out her complete story at www.gulnarasamoilova.com

Anniversary of 9/11

I was not invited to the memorial ceremony and did not want to go. I was afraid. Not so much for the visit to the site itself. It was the people that I was afraid of. It was the immersion again into that immense pool of grief and sorrow and memory. It was fear of the unknown, like diving into an abyss. How can that not change one forever? What would I emerge as when I reached the other side?

I had been back to Ground Zero several times by the time the first anniversary came around. The first time had been to deliver my images to the police command, and then I'd been back three subsequent times to try to recover my car. I knew that the site no longer presented the apocalyptic vision that I had witnessed on my first visit. Sergeant Pete DeMonte called me the day before the anniversary and was pretty insistent that I should go. I thought about it for several hours then called him back to ask if would be OK for me to bring

someone with me. He told me it wasn't a problem (which is his way of saying that there is no problem that cannot be overcome). I called my brother Frank and asked him if he wanted to go with me to the anniversary. He did.

An hour or so later my friend Michael Fox called. He was also reluctant to be alone on the anniversary. When I told him that my brother would be with me, Michael was gracious but I could hear the disappointment in his voice. I made another call to Pete DeMonte, and asked if he could he handle three?: "No problem, no problem at all. Just be at 25th and Park at 7:30. Glad to do it".

Pete was coordinating an army of tow trucks that needed to move thousands of cars deemed in the way of the ceremony in lower Manhattan. He greeted us between taking calls and barking orders on the radio. The three of us climbed into the back of the patrol car

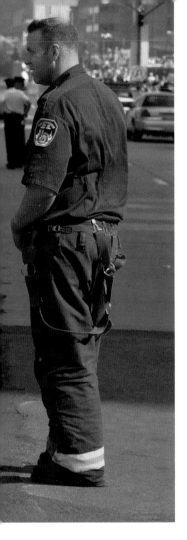

and headed, lights flashing and sirens blaring, toward lower Manhattan. I looked over at Frank, remembering his September 11th story, and searched his face for a trace of recognition of the irony of our situation. When the towers were hit, Frank was on a train somewhere on Long Island. Louise had reached him by cell phone to tell him that I was in Tower 1.

He immediately made his way to Brooklyn Heights thinking he could somehow get over the Brooklyn Bridge and find me. He headed onto the pedestrian walkway toward Manhattan against a steady stream of evacuees.

He made it a quarter of the way over the bridge only to be turned back by the New York City Police. Frank is large and can be insistent, and he isn't easily intimidated. He got into a heated argument, first with

two officers then four. They ended up restraining him with handcuffs. Luckily, one of the officers recognized him from the neighborhood and grabbed him by the arm telling his fellow officers, " I got this one". He was taken to a precinct house in Brooklyn and put in lock-up without arrest. The officer told him his detention was a "timeout".

Between making introductions and giving advice as to what we could expect and where we were likely to go, Pete barked orders over the radio. His partner, a big man, (I don't know how tall he was but he was wider than Frank, which is saying something) calmly made small talk while averaging 70 mph through the streets of lower Manhattan— It's amazing how quickly you can get from 25th street to Fulton Street in a police vehicle. At Fulton Street we said goodbye to

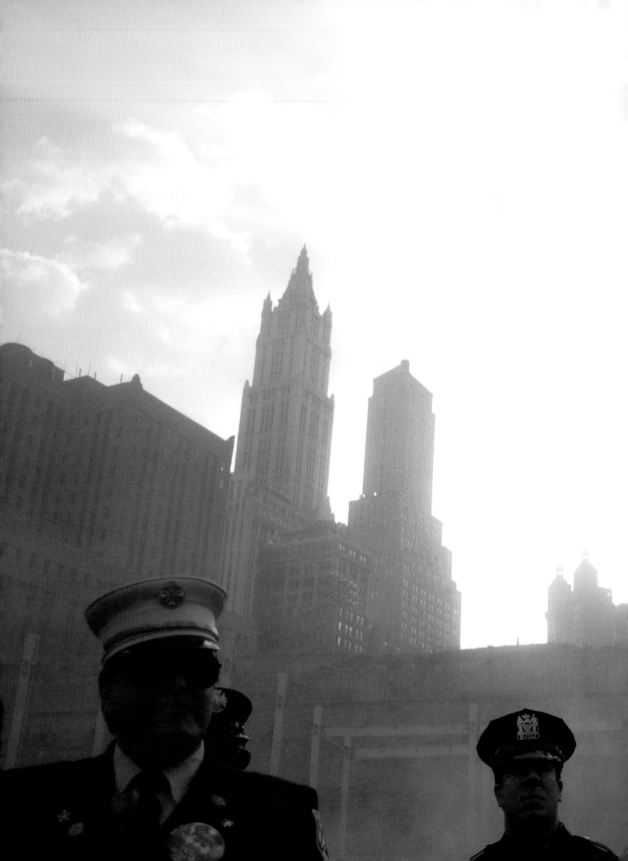

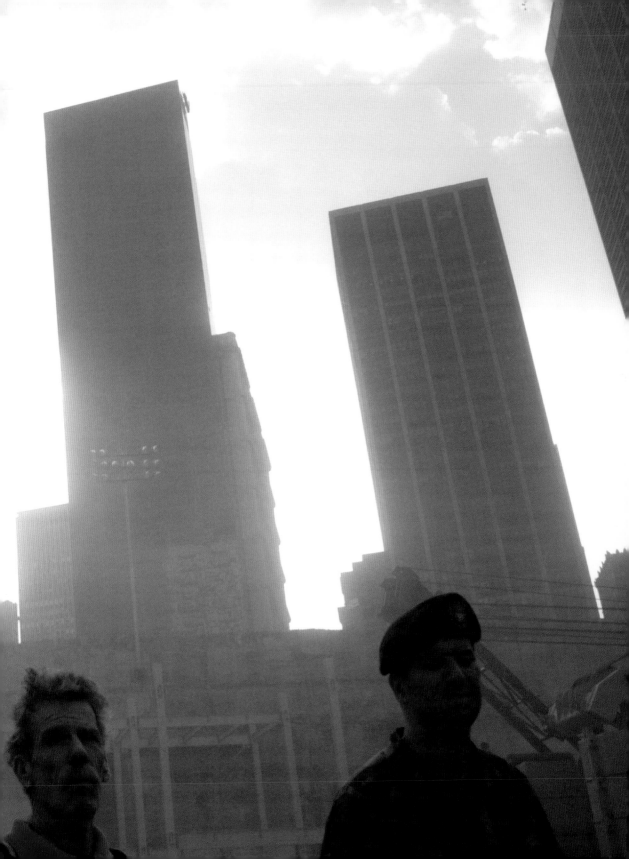

Pete's partner, and Pete escorted us to the ceremony on foot. Security was extremely tight. Pete knew where he wanted to take us but the wasn't sure exactly if he could get us there. He ran down the details of a series of backup scenarios, in case we should we need them. We passed through three checkpoints (twice Pete asked us to wait while he went on ahead securing permission for our passage). He led us through a gate at the southeast corner of Ground Zero, not far from where the south pedestrian bridge had been, before its destruction beneath the collapse of Tower 2. The gate let out to a walkway that doubled as a waiting area, running the length of the southern perimeter fence around Ground Zero. Just to our west was the ramp that led down into the pit, where a ring had been erected in the center as the focal point of hallowed ground. The weather was not unlike the day exactly one year earlier, except for the wind and the occasional cloud drifting by. We were in an area reserved for family members of the deceased. We were early, but not as early as the army of volunteers everywhere distributing roses and orchids, and handing out bottled water and snacks.

The area filled to capacity I don't know what the official count was. There was a disconnect between sound and activity created by the great open space and the echoes created by of the foundation walls and surrounding buildings. We watched the honor guard descend into the pit and form an outer ring around the circle. Then it was our turn to follow in procession. As we descended into that hole the wind whipped up and I could taste again the mix of ash,

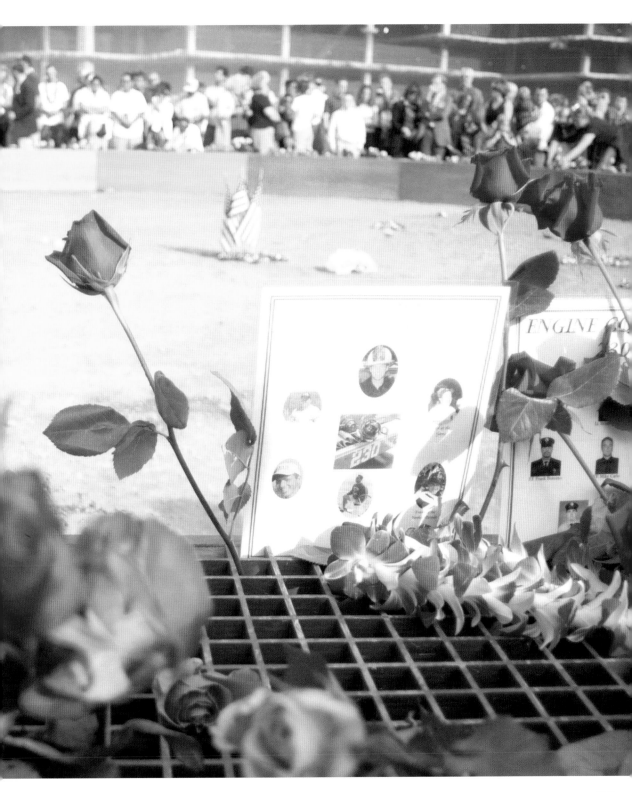

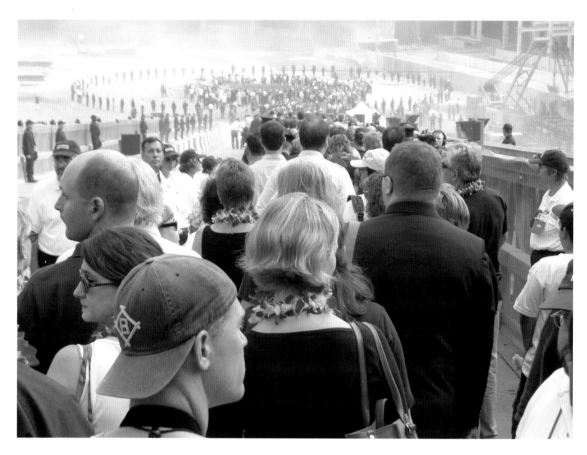

concrete and steel. It stung my eyes, which were already starting to tear.

I was two months old when my father died; Frank was three and a half. As I looked at all these people I saw myself, and I understood for the first time what I could not have known as a baby. In a thousand wives' faces I saw my own mother grieve for the loss of her husband, three children by her skirt, her face set against the prospect of an uncertain future. In the faces of the children around me I saw my own brother and sister grieving for the loss of their father. In elderly faces I saw my uncle and aunt and grandmother grieving for the loss of their brother and son.

We were standing on what looked like earth, sand and pulverized building. The wind picked up even more, creating dust devils and mini sandstorms. People covered their eyes and mouths (I'm sure I was not the only person wondering just how toxic was this dust we now found ourselves again covered with). It brought me back to that day. It was a baptism of a sort

for the uninitiated, a way for the families to taste what their loved ones surely tasted on 911. I found it unnerving, it raised the hairs on the back of my neck. It filled my nostrils and lodged itself in my eyes, ears and hair. I had to remind myself that it was not the same day but three hundred and sixty five days later.

I left Frank and Michael near the inner circle and shrank back from the crowd so that I could see the site better. I searched the corners of the pit for some sign of its former self. From the belly of the pit the sheer scale of the place is what was most striking. Especially looking westward, up at the buildings of the World Financial Center. The figures of the public looking down into the pit from the terraced walls were reduced to ant-sized proportions. The pit was bounded by what the designers affectionately called "the bathtub". It bore no resemblance to what most of us remember of Ground Zero in the early days following the attack. Gone was the concrete and twisted steel from the collapsed buildings. What was left was much more than a

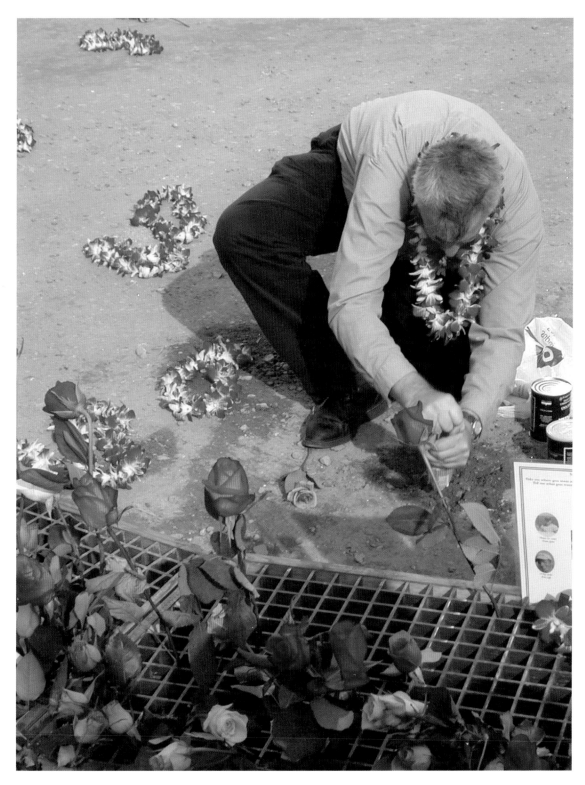

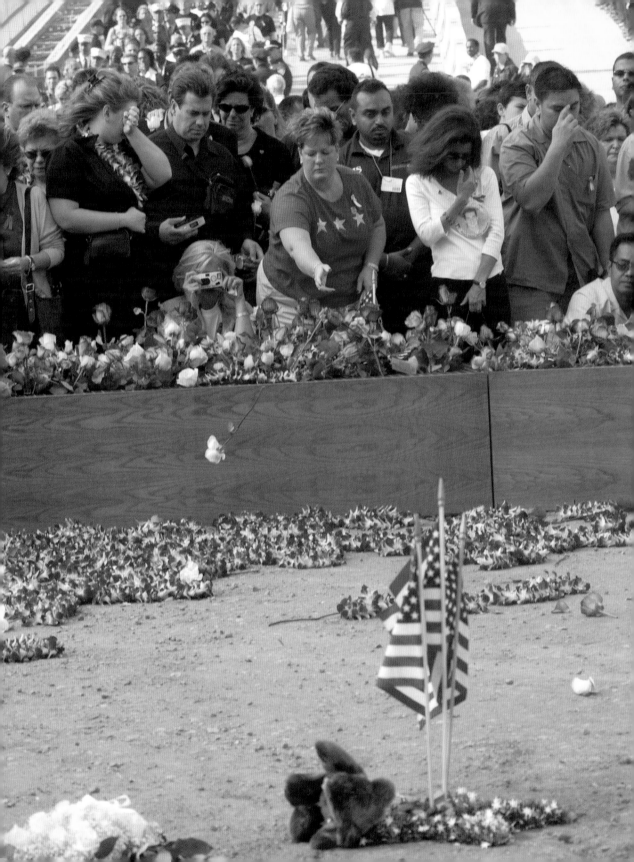

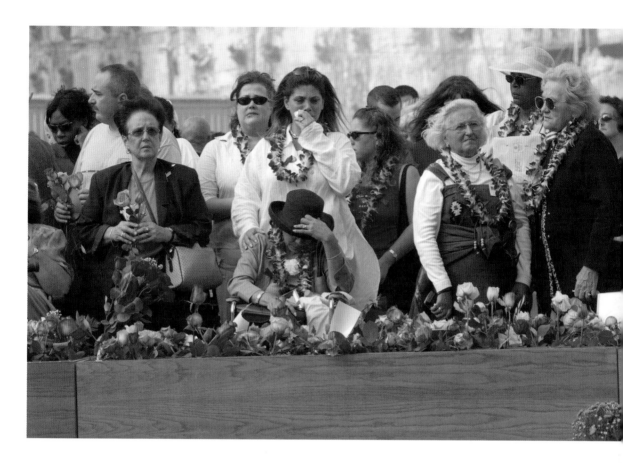

construction site or an empty hole in the ground, but that is the impression a first time visitor viewing the pit from above might come away with.

The concrete bathtub forms the perimeter wall of what was once a seven-level basement. The 500-feet-long north and south walls, and 1,000-feet-long east and west walls are 70 feet high. Much of the towers' debris that had crashed into the basement had compacted and replaced the floor slabs that supported the walls—I remember one report of a lobby sign having been found seven floors below grade. In order to remove all this debris safely, a huge, complex construction effort had to be orchestrated to pin back the bathtub walls. I looked east, west, and south; some of the original sub-floors, and what looked like part of the subway system, could still be seen, mostly at the north end. It was here that the pit looked less like a construction site and more like a ruin of the Towers. I touched the walls and picked up the soil and held it in my hand. As horrible as it was to recognize the scars

and touch them it allowed me to connect to what had really happened here. I was somehow comforted by this less sanitized place.

We were on common ground, I was in Tower 1 when it was hit, I had lost friends, and my heart was broken too, but I felt like an interloper. I had brought my camera, which added to my sense of being outside of things, it also forced me again to look hard at what was in front of me. I realize now that I was searching for something, the way I had been searching on 9/11 one year ago. I was using the camera as a buffer and a tool from which to engage this thing and try to process it. It is a paradoxical relationship that gives you distance but at the same time forces you to look closer. There was a young boy maybe twelve or thirteen who had also pulled back from the crowd. He could have been bored, or curious, or just sad and wanted to find some space, I don't know. I watched him kick the dirt for a while, the dust devils chasing him. I watched him walked about like me searching for something. He

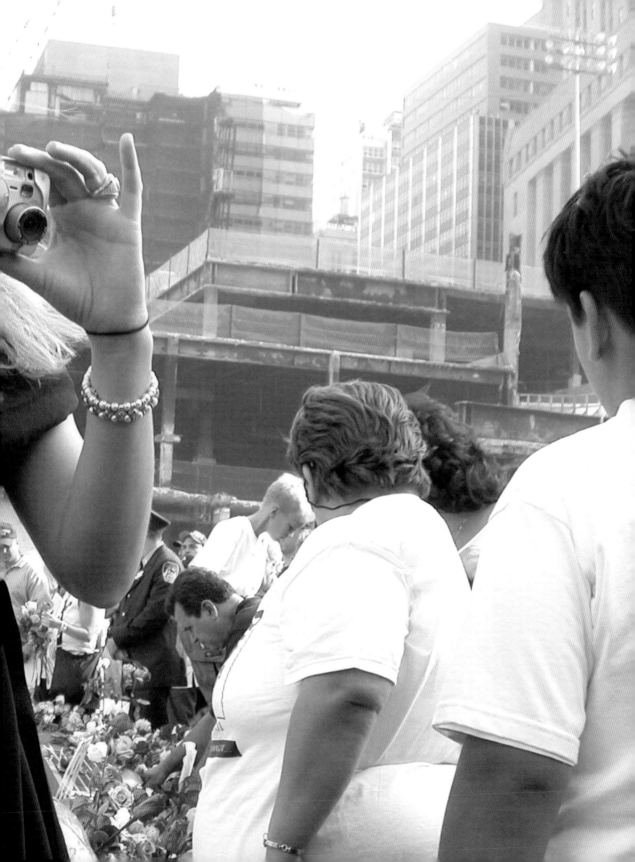

would pick up an object, examine it and throw it away. For a second I thought he had found what he was looking for. Then I saw him look back to the circle and I could not help but cry.

We had been in the pit for an hour. I made my way back to the circle, and found Michael and Frank. We made our way back up the ramp and headed over to West Street then south to the six train subway station in Battery Park. Our clothes and shoes were covered in dust, we could taste the grit in our teeth and feel it in our hair, ears, and noses. It was another 9/11 of a sort and again we had survived the day. We got on the subway, Frank had to go back to work and then home to his wife on long island. Michael and I got off at 14th street— we were meeting our wives for lunch in Chelsea.

At the restaurant I washed in the restroom. I looked at myself in the mirror as I cleaned the grit from my eyes, scalp, and from behind my ears. But I couldn't wash the day from my mind. Now that the ceremony was over I tried to imagine where Jenny would have been on this day had I not made it out of the building. Would she have gone home alone, much like my mom had done forty year's prior but without three children to comfort her and worry over? Would family and friends have comforted her? Would she have gone back to her mother's home? I tried hard to look at the thousands of people whose lives had become so intricately wrapped up in this day and grasp what was reality for them. But, in the end, what I saw was merely a reflection of what I had already experienced in my own life. I was one of the lucky ones. I prayed I would go forward without guilt for my good fortune and that I never forget what a gift each day is.

In the summer of 1998 my faith was first truly tested. From this experience I learnt how to have conversations with God. I discovered that I needed to stop bargaining with Him in order to let His blessings flow to me. Prior to that year I prayed as I had been taught to, as a child. This new emergence of Spirit would be the strengthening of my soul. In the summer of 1999 I was again tested and while most people believed I was simply lucky to have survived, I knew that it was the power of the Spirit. My soul emerged stronger than before.

Tuesday, September 11th 2001 marked the beginning of my third test of faith. My Spirit and soul became as one, and I now begin to fully understand the power and the glory of God, and the Holy Angels who He has placed among us as instruments of His love and care.

I had just completed reading my mail at about 8:45 a.m. when I heard a loud booming sound. I was located on the 71st floor, at the northeastern corridor of World Trade Center Tower 1. Since my office was located alongside the windows, I immediately moved to the center of the floor and looked eastward. To my horror I saw smoke, flames, and debris shooting down from above us. I felt the building shudder. Suspecting that a small plane might have slammed into the building, and trying to ignore the pounding of my heart, I started to move. I knew instinctively that I had exceeded the number of racing heartbeats permitted before my defibrillator would issue a jolt of electricity. It went off almost immediately and I desperately tried to fight off the terror I felt and remain calm so as to avoid another jolt. I doubled over and immediately several of my colleagues came to my aid. While one of them was on the telephone trying to reach our medical department, the director of my division came hustling down the hallway ordering everyone to vacate the building. I heard a gentleman say to others who were hesitating, trying to determine whether they should stay to assist me, that they should leave because "he had me". I was sitting in a chair desperately trying to maintain control and stay calm in order to prevent my defibrillator from going off. Here I was with a bad heart, bad lungs, swollen, heavy legs, and the speed of a snail at best. I knew that I would have to be exceptionally strong in order to be able to walk all the way down to the street. All I could think of was "God, if this is the way you wish me to die, then Thy will be done, but please, no pain". It was only then that I looked up into the face of a six-foot, slender young man whom I'd never met, who told me to "stay calm, and get up, we are going to walk out of this building together". His confidence gave me strength to move my heavy legs, and head toward the doors with him. When I asked his name he softly replied, "Paul Carris". I told me mine, adding that he might not understand but that he was my angel for the day. He simply smiled. Paul led me into the stairwell of the 71st floor, and told me to take hold of the railing with my right hand. He placed his left hand under my arm and we started down the stairs.

As we descended he would let me rest on each floor. My breathing was labored and I was having difficulty walking, but Paul firmly pressed us along. I watched in horror as a woman I knew from the 88th floor came crashing past us, fleeing down the stairs. She passed us in a flash but not so fast that we couldn't see that the skin on her back had been burnt off, and had rolled up to her neck like a macabre travesty of a necklace. I pray that she's alive and getting well. I began to realize that we were in an extremely life-threatening situation.

Several times, others stopped on their helter-skelter journey down the stairwell to ask Paul if he needed assistance helping me. They rounded up a face-mask for me and supplied us with water before continuing down. Paul asked some firemen to give me with some air, which they did, and I was so thankful for the generosity of people who were willing to help, in spite of the danger they were in.

When we neared the 40th floor some firemen and police officers moved us to another stairwell, since the one we were in was too congested. As we walked across the hallways to get to the south-side stairwell the stench of jet fuel permeated the air and we saw that a ceiling above one of the corridors had collapsed.

Once inside the stairwell, Paul allowed me to rest for a moment before continuing downward. My air passages were becoming constricted, and he encouraged me to breathe as deeply as I could, and to take slow, even breaths. He kept wetting my facemask to cool the air I was breathing; as soon as I felt my lungs relax I knew that I could take another step.

Somewhere along the descent below the 30th floor, we felt more than heard another loud boom, along with a terrific blast of wind that made the building shake. Firemen began running up the stairs with more urgency, and I felt my defibrillator jolting my heart. Paul drew me close to him in order to ensure that I did not lose my footing and fall as people tried to rush past us. He talked to me very quietly about remaining calm but I could feel his fingers tighten every so slightly around my arm. One of Paul's co-workers tried to start a conversation about the cause of the blast, and out of the corner of my eye I saw him shaking his head, telling him not to say anything that I might over-hear. In my terror I thought that it was our building going down, but later I learned about the evil that befell Tower 2..

As we approached the 20th floor, firemen came running down the stairs yelling to us "Move, move, keep moving". If there is such a thing as controlled terror then that's what I felt. I knew that we were in danger but I didn't really believe that we would die in the building. I could now feel the urgency in Paul's steps and we were no longer stopping for me to rest. My left knee buckled, I was no longer able to bend it, and my right leg became totally numb.

I saw the glimmer of gold on Paul's left hand as he reached over to shield me from people rushing past us and I realized for the first time that he was wearing a wedding band. He was married and I suspected had a family. I asked him to leave me behind and save himself since he had a family and I was moving much too slowly. My words fell on deaf ears as he instructed me to swing my left leg forward and drop my right foot to the next step. He assured me that he would never let me fall. At this point it felt as if we were floating down the stairs. When we arrived on the 10th floor Paul began counting down the floors, encouraging me by telling me how well I had done coming all the way from the 71st floor. Now, we could smell and see smoke rising from the floors beneath us, and the trip became more arduous and even more urgent. The staircase was flooded with water and I could feel it dropping on us from above. My heart was thundering in my chest and I could barely grasp our success at reaching the first floor.

When Paul opened that door and pulled me into the lobby I was totally unprepared for what I saw, even though I now fully realized that the building was under attack. There was broken marble and glass everywhere. What was once an beacon of gleaming sophistication was now rubble and ruin. I could hear water running like a gentle fall amidst the chaos and carnage. I had noticed on our way down the stairs that some of the women had taken off their heeled shoes and left them in the stairwell on their hurried journey downward. Now I could hear cries of pain as they stepped on the glass with their bare feet. The saddest, most poignant memory was seeing people turn to the left as we came out into the lobby: this was choosing death since it led into the concourse of the building—and some of our companions did so.

Paul urged us to the right, out onto West Street. I could barely sustain my body on legs that had every muscle screaming, yet were numb at the same time. I looked at him with a mixture of relief and terror—realizing that we had made it out of the building but were now standing, almost alone, at the base of a building which he knew to be unsafe since he kept urging me to move away from it. It was much later before my mind would let me accept that we were forced to stumble over some of the bodies of those who had perished before us. We turned and headed toward Vesey Street, with me leaning heavily for support against him. It struck me as odd, when I saw someone taking our picture as we struggled down the street. I couldn't fathom how he could be interested in us while we were in the midst of such devastation.

Paul led me to an ambulance parked on Vesey Street, where a paramedic placed an oxygen mask over my face. Less than a minute passed before a fireman came running up to the ambulance yelling that the ground beginning to shake and the buildings around us were probably collapsing. Paul took the oxygen mask off of my face and urged me up Vesey Street towards the Hudson River. As we moved toward the

next block west of West Street we heard a loud rumbling noise, and when I looked back I saw the place that I had always been in awe of, which many of us knew as well as our homes, fall crumbling to the earth. We ran and made it to a building on the corner as debris, dust, and smoke came crashing behind and past us. My heart bled for all the firemen, police officers, paramedics and other rescue personnel, as I remembered them running up the stairs as we were coming down.

A fireman yelled for us to get into the building that had shielded us from the collapse of Tower One. Emergency workers followed us and began setting a triage station for the injured rescue personnel. Men and women were running about, taking care of their comrades and trying to get mud and dirt out of eyes, ears and mouths. Someone strapped an oxygen mask to my face and I was able to breathe much more comfortably. Paul went to get us some water and it was then that I realized he was beginning to feel the effects of what he had just accomplished. No words passed between us but he looked into my eyes and I into his, and held his hand and watched as tears fell gently from the corners of his eyes. I have never been so moved by anything as I was by that moment; but it was not yet over.

After about 10 minutes a fire marshal ran into the building screaming that the gas lines were exploding and that we had to get out immediately. We found out later that there was a secondary collapse of Tower One. Gurneys began to roll, people began to move out into to the street where ambulances were waiting for broken bodies. Paul and I were standing in the street uncertain as to where we should go. We were the only two civilians there as far as I could tell. A woman urged us into an ambulance where a man was already strapped in, and in a flash we were moving down the street amid a second storm of dust and debris.

The man on the gurney was a fire chief with a suspected back injury, the paramedic was an off-duty policewoman from the 34th precinct. She refused to go to any of the downtown hospitals, choosing instead to take us to Columbia Presbyterian Hospital in upper Manhattan, where we would be assured of immediate medical attention. We could not get off the exit to Columbia Presbyterian and wound up at an annex of the hospital on West 220th Street and Broadway, near the Bronx border. I am thankful to the driver who made the arduous journey, weaving in and out of the bumper-to-bumper traffic heading uptown. When we arrived at the hospital and they wheeled us into the emergency room area, I was struck by how quiet it was. Usually emergency rooms are busy hives of activity, but I realized that most employees were following the madness on television. The doctors and nurses in the emergency room assuring us that we were safe and that all would be well. I was grateful for the peace and for the quiet.

Paul remained in the hospital until he knew I was being taken care of and then cleaned his dust and grime-ridden clothing as best as he could in a bathroom. Then, as quietly as he had come into my life he left, telling me that he wanted to get home to his family. A little later a priest came into the room to comfort me, and asked if there was anything he could help me with. I told him that for the past few years, every time I had been brought out of a crisis through my belief in God, people would tell me that He had something special for me to accomplish on this earth, and that I should find out what it was and do it. I had been troubled that I could not determine what that "something" was. His response was so simple that I am surprised I hadn't thought of it myself. Father Thomas stated that my strength, endurance and belief in God is what kept me alive. He told me that when people looked at my struggles they would see evidence of a living God who has blessed us in many ways. This, he said, was probably what God wanted from me, nothing more than to live as a testament to what belief in Him could do.

I grieved for the many who had lost their lives, for the faces vivid in my memory even after a fleeting glance. I have been through many crises in my life, and each time I've asked God to send me His angels to help me through the pain and trials. He has never failed me. This time He sent Paul, a courageous, caring man, to lead me out of destruction and carnage. It had taken us about 90 minutes to descend to safety; later I learned that we were very likely the last two people to come out of the building before it collapsed. Thank you, Paul, you will stay in my heart forever. I am forever grateful.

Epilogue

Since September 11th I have found it impossible to explain what has happened in my life without addressing spirituality and religion. What I am challenged with now is overwhelming. I won't even try to pinpoint just where I am on this road, but I will tell you that I realize now that I am on a journey. Part of what I have to do going forward is to educate myself well beyond anything I've achieved thus far, especially about religious and cultural traditions.

Though my mom taught Sunday school for a while, she left us to follow our own paths. I was raised a Roman Catholic and like many of my generation I felt the church and its rituals out-of-step with what I could accept as a rational thinker. .

In 2002, my mom's health began to deteriorate to the point where she had trouble taking care of herself. You have to understand my mom is no stranger to pain. She has outlived two husbands; is an 18-year breast cancer survivor; had lost a lung to emphysema as a young woman; and has had multiple back surgeries, once requiring fusion. Mom has never let any of these things slow her down for long. In November of 2002 she had planned to attend a religious pilgrimage to Lourdes, France along with 80 other members of her church, St. Bernadette's. She had been helping to prepare for this trip for a year, so when her health deteriorated to the point that she considered not attending, I knew she was likely in much more pain than she was admitting.

There was no way she was going to be able to attend this trip without a wheelchair and someone to push it. My mom is a woman of great strength and faith. She had tried everything and now she needed me. I cleared my schedule, and arranged to meet her in France. I decided to treat the trip as an assignment. I was to be the pusher, porter, and cameraman.

Like so many millions before us we had come to take the waters, and we did not go away disappointed. For me Lourdes was a contradiction and a puzzle. In November there are no crowds but the signs of the commerce they bring to this town are everywhere; there were hundreds of hotels and souvenir shops many of which were boarded up for the winter months. We spent three days in Lourdes; we drank from and bathed in the waters. And prayed before the virgin in the grotto. In between praying, bathing, sleeping, and eating, I pushed my mom in her wheelchair and cajoled my aunt to follow us up and down the many hills and through the narrow streets of this, despite the commercialism, very beautiful city in the foothills of the Pyrenees.

On the third day we bid farewell to Lourdes and piled back into our buses for what would turn out to be a marathon. We headed north and west through the Bordeaux region to visit with The Sisters of Charity at St. Gildards Convent in Nevers France. Here is where Bernadette came after leaving Lourdes and where she lay incorrupt within a glass casket in the convent chapel. The next day we were off to Normandy and Mount St. Michele, followed by another long day beginning with a tour of the US military cemetery at Normandy beach.

I wasn't prepared for the magnitude of the place. The effect of seeing these grave stones against this extraordinary meeting of sky, sand, and water took me back to Ground Zero. The toll in human terms was unimaginable. Again I found myself peering through the eyepiece of my camera mesmerized by the visual and contextual richness of what filled my frame. How can something so beautiful be so sad?

I realized then that it was the irony that beauty should be juxtaposed to great tragedy that was the common thread that pulled me back to 9/11. I asked myself before why was it that on 9/11 I sought beauty amongst the ashes caused by the pyres of more than 2800 deaths. And I have to say I didn't know exactly why it was so important for me to do that, but it was. And here I was 4000 miles away at the site of another tragedy. I was again working the controls on my camera, trying to mine beauty from this other place.

It was here that the price of war was inescapable. It was here that this young man who had learned of war from John Wayne movies made the leap from fiction to reality. When I looked at the graves I saw these young men just as I had seen the fallen on 9/11, and I thought, what beauty was there in that?

My mom had never been to Paris and after 9 days on the road we all were in need of a much-needed break from the bus. It was Tuesday November 19th, my mom and aunt were flying out on the 21st, which

happened to be my birthday. Jenny had managed to get a few days off from work and had booked a last minute trip to meet me in Paris for the weekend. The next few days were spent exploring this most beautiful old European city. It wasn't long until my charges and the parishioners of St. Bernadette's were to go home. On Thursday morning I checked out of the hotel along with the rest of the flock and took the bus to Charles DeGaulle. Jenny had caught a redeye out of Kennedy and was landing about the same time my mom's flight was taking off.

When Jenny emerged from customs she was beaming; I was so happy that she was able to make it, it was the best birthday present I had ever had. We both loved Paris and had good friends here. We headed back to our Hotel. Jen wanted to wash off the effects of the flight. She also had brought a small package with a birthday gift that she was now anxious to give me. I am not the easiest person to buy for. I had almost forgotten that it was my birthday; and I thought her coming to Paris was a gift in itself. She was so excited, that I began to wonder what it was. She positioned herself carefully on the couch so that she could watch as I opened my gift.

Beneath the paper was a small, beautifully carved, leather jewelry box. She could tell I was pleased. I opened it up and inside it were two pairs of infant's socks, one yellow, one white. We had been trying to get pregnant for two years, since visiting our Parisian friends Tamara and Valerie, and being inspired by how how these wonderful people were raising there beautiful child, 9-month-old Leonard. I looked up at Jenny and we both started to cry.

I came upon this quote from St. Therese Couderc while writing this book:
I saw written as in letters of gold this word Goodness, which I repeated for a long while with an indescribable sweetness. I saw it, I say written on all creatures, animate and inanimate, rational or not, all bore this name of goodness. I even saw it on the chair I was using as a kneeler. I understood then that all the services and helps that we receive from each of them is a blessing that we owe to the goodness of our God, who has communicated to them something of his infinite goodness, so that we may meet it in every thing and everywhere.

I can only think that if St. Therese had gone into a Hebrew Temple or a Mosque or read the Koran, or opened the Torah or gazed upon a Buddhist shrine, she would have surely seen the word Goodness written there as well.

I have been critical for so long of my own religious tradition - I was raised as a Catholic - but I realize now that if I look at Christianity with fresh eyes I can see the Goodness that is God shining through despite the veil of man.

And in this light, I can't help but think that in all my searching for beauty and meaning in the graveyards of Trinity Church and Normandy Beach, that what I was seeing was Goodness there as well. Wasn't that the lesson my grandmother had taught me? To find a gift in the aftermath of a tragedy?

Was it not Goodness in the form of salvation that came to man through Christ's passing? Isn't it goodness that is the end of death and goal of reincarnation or of any religion for that matter that connects a virtuous life on earth to a glorious afterlife? Isn't the doorway to heaven a mortal death?

On September 11th 2001 I learned something that I would otherwise never have known for certain. I learned that people in the face of great evil are basically good. And I learned that doors open for a reason and our job is to find the courage to step through.

Within a few months of our trip to Lourdes, my mom's health problems disappeared; my family and extended family are all amazed at her recovery. When someone sees her now after they had seen her then, they always ask, usually in a whisper, "do you think it was the waters? Do you think it was Lourdes?" She is a miracle I say, but then again to me she has always has been a miracle.

This book has been my catharsis, but it is only a beginning. A month from now by the grace of God I will be a father for the first time. In all my searching I cannot conceive of a greater gift or a better view from which to learn about the world and learn about myself than through the eyes of a child. I pray with all my heart and soul that I remain open and eager to accept the lessons that I will surely learn then. I am grateful for this life with all its twists and turns and for this opportunity to live it well.

The following is a complete, unedited transcript of the original account written by John Labriola following the attacks on the World Trade Center. It was posted online alongside his Photographs on September 14th.

World Trade Center
September 11, 2001

I was there, it is so terrible, but I'm okay. Many people weren't so lucky. I had started a new contract for the Port Authority about two weeks ago. I drove in that day down the East River Drive and parked in a lot three blocks south of WTC 2. I started taking pictures through the window of my car from the time I exited the drive. The light was beautiful that morning, at 8:05 I took a photo of the trade center and the Greek Orthodox Church that shares the lot with the parking lot just south of WTC2.

The PA had given me a cubicle on the south side of the 71st floor of WTC1 (the north building). At 8:30 I was in a status meeting on 71 East. AT 8:47 the building rocked first in one direction then shuttered back and forth and finally settled. None of us were hurt or knocked off our seats but getting up while the building was moving was difficult. The building felt like it had moved at least five or six feet in each direction. From the conference room door I could see out the window. The sky was so blue, papers were flying everywhere. It looked like a ticker tape parade. We speculated from the start that we were hit by a plane. I ran around the floor to the south side of the building grabbed my backpack, and laptop. Everyone was off the floor pretty quickly. The guy I report to and I headed out to the lobby.

One of the stairwells smelled strongly of smoke. The other seemed okay and we joined a group of others already beginning the walk down. Everyone handled it so well; we all helped each other. We walked down two by two stopping every so often for some unknown reason. Some people were helped down from higher floors with terrible burns over their bodies. Whenever necessary we would press ourselves into a single file line to let people get by. It was pretty hot; people were slipping on the sweat of the people who had come before them. In some places the smoke was worse than others. Thank god the lights always stayed on. People covered their mouths and eyes with whatever they had available. When fears bubbled up there were always reassuring words from the right person that calmed even the most frightened of us. I was told from someone who was on 81 that there was fire on his floor immediately after the first plane struck.

When the second plane struck we felt it, but had no idea what it was. It wasn't until someone began getting news on his pager that we knew that a plane had hit each of the towers and the pentagon. People constantly were checking their cell phones to see if there was service. Many of us had service but no calls could get out. I remember joking that we should all buy stock in the first company whose service worked.

Around the 35th floor we started meeting a steady stream of firefighters walking up and had to press into single file again. None of them said a word as they went up and past us carrying unbelievable loads of equipment. They were already exhausted by the time we started seeing them. I can't stop thinking about the look in their eyes and how heroic they were. I remembered then that my camera was in my bag and began taking pictures of the men as they went up. I pray some of them made it out.

A few floors lower water was flowing creating rapids down the stairs. This got worse as we got lower down. The stairwell led down to an outside door lined with emergency workers urging us to move to safety. There was debris and broken glass everywhere. The courtyard where this outdoor landing led us onto must have been blocked or too dangerous for us to cross because we were directed back into that second floor balcony again and down two escalators into the mall under Tower 1. Water was falling everywhere - 8 to 10 inches in some places. Many of the stores had windows blown out. All along the way emergency workers urged us to keep moving. I went up another escalator in the north east corner of the mall under building 5 and out onto Church Street. I was outside; in all it took 60 minutes to get down, as I stepped into the light, emergency workers were yelling "don't look up keep moving" I crossed the street and looked up. It was unreal. I saw someone fall from Tower 1: I stopped looking up.

Many people were just watching the buildings burn from Church Street up to Broadway. People I knew were helping each other gather themselves. I stopped to help calm a co-worker. I shared my cell phone with people desperate to get word to loved ones that we were okay. The phone didn't work. We talked about what to do next. I looked at the ground around us and there was a lot of blood. Some shrapnel caught my attention I couldn't stop thinking that it must have been from a plane. Shoes where everywhere, newspapers and blood. When I looked up the people I was with were gone. I thought I would head south toward my car so I headed east and the south down Broadway.

As I neared Wall Street I noticed the doors to Trinity Church were open so I stepped inside. A priest was leading a prayer service; I knelt to say a quick prayer and seconds later the first building fell. The stained glass windows that were filled with color and light turned inky black. You could feel it as much as hear the building collapse. Debris hit the

roof of the church. People dove under pews. I looked out the front door, I couldn't see three feet in front of me, I thought it must be impossible to breath outside. We gathered everyone inside the church, and made plans to evacuate. We searched the church, found some water, food and made up wet towels for people inside and out should we need to leave the protection of the church, we waited for the air outside to be clear enough to see. Someone found a radio and positioned it on a pulpit.

It grew lighter outside the church. A few minutes later my cell phone rang, it was my mother in-law calling from Holland. I asked her to call my wife and mom. Up until then no one's cell phones had worked. I tried but still couldn't call out. In looking around the church I found a phone that worked and was able to get a call out to my wife at her office in midtown. She was devastated. She knew I was in the building, as did some of my close friends whom I had spoken with at 8:15. She told me that my brother in law was on his way to get her and take her to his apartment in the west village. I promised to meet her there. Minutes later the second building fell. Blackness again, larger objects were hitting the roof of the church, we had relatively clean air inside but there was a lot of deliberation about whether it was safer to stay in the church or take our chances outside. 40 minutes or so later it was again clear enough to see across the street. We said our good-byes to each other and in groups of two and three ventured out to find a way home.

There were three of us in my group. Outside it was a mess. Winds would whip through the streets causing temporary white outs and blacking out the sun. I remember thinking that they must have been caused by the draft from the fire. Emergency vehicles caused their own white outs and you would have to hide your faces as they came by. The group I left with headed south then east then north. We passed others leaving the area and some firefighters heading in. At the Water Street entrance to the Brooklyn Bridge we said goodbye to one of our party and two of us continued north through Chinatown and into Soho. All along the way people were gathered in disbelief. Radios drew large crowds. I remember someone talking on a cell phone telling his friend that no one above the 60th floor could have gotten out. I told him that that wasn't true, that I had walked down from 71. He called after me, "Thank you sir thank you". I just kept walking. I stopped at different places where I knew that I should have seen the towers. I left my last companion in Soho and wished him well.

I made my way to my sister's house where my wife fell into my arms. I can't imagine what she felt like not knowing. I can't imagine what it's like for thousands of others whose loved ones didn't get home. My heart breaks for them. From talking to people in the stairwell at least I know that some people up to the 81st floor got out okay. I'm grateful for that, I hope everyone got far enough away before the first building fell. I'm incredibly lucky, and incredibly sad.

Since September 11th I've talked to many people who were inside that day and many more people who watched and waited. I'm encouraged by how everyone treated one another in the stairwell and since. Each person I meet has a story to tell and an urgency to press the flesh; It's important to reassure oneself that the person in front of them is real. For me It's incredibly important to feel useful. Like so many of us, I've been actively trying to account for as many people as possible. It's also important for me personally to get the right message out. In the stairwell, people treated one another so beautifully. No one stopped to think what color or religion the other human being was. We were all in this thing together. And this is how I pray people go forward from here. I'm not a Buddhist, or particularly religious but I do believe in God. Personally, I look at all religions as trying to explain the same phenomenon. I've never understood why people choose to kill one another over whose explanation is better. On September 11th a lot of you went through the unimaginable. For many the suffering is far from over. Please if you read this, don't let my story or anyone else's become a reason to lose your head rather than use it. I had the book The Art of Happiness by His Holiness the Dalai Lama and Howard C. Cutler in my bag when all this happened. The following is an excerpt from the page I had book marked. It seems to me a practical approach to beginning the journey ahead. I hope this helps.

..."Although you may have experienced many negative events in the past, with the development of patience and tolerance it is possible to let go of your sense of anger and resentment. If you analyze the situation, you'll realize that the past is the past, so there is no use in continuing to feel anger and hatred, which do not change the situation but just cause a disturbance within your mind and cause your continued unhappiness. Of course, you may still remember the events. Forgetting and forgiving are two different things. There's nothing wrong with simply remembering those negative events: if you have a sharp mind, you'll always remember, he laughed. "I think the Buddha remembered everything. but with the development of patience and tolerance, it's possible to let go of the negative feelings associated with the events."

- His Holiness the Dalai Lama

God bless
- John Labriola

Acknowledgments

In Memory of Doug Karpiloff, John Fisher, Keith Rona, Paul Tava, Troy Neilson, Nanny, and the "Old Raison"

The author would like to thank the following:

Ben Agger, Bobby Baker Burrows, Brad Herbert, Chuck Zoeller, Daisy Ho, David Brondolo, David Friend, Ed Bonny, Ellen Nanney, Frank Labriola, Garry Hundertmark, Graydon Carter, Gulnara Somoilova, Gus Yoo, Hal Buell, Judith Toppin, Karen Prince, Lou Reda Productions, Louise Labriola, Mia Stern, Michael Keogh, Michael Stern, Michelle Delainey, My Mom, Mort Saul, Paul Carris, Peter Demonte, Safwat Wahba, Sean Moore, Sys Morch, Tricia Moore, The Associated Press, ABC, Good Morning America, The Fire Department of the City of New York, The Police Department of the City of New York, The Port Authority of New York and New Jersey, Time Life Books, Vanity Fair.

This book is a result of the generosity and character of so many people, if you helped me, you know who you are. Know also that you have my thanks and gratitude.

All photographs by John Labriola except for pp. 86-91, David Brondolo; 162-163, Gulnara Samoilova